THEY PAINTED FROM THEIR HEARTS

IONEER ASIAN AMERICAN

ited by MAYUMI TSUTAKAWA for the WING LUI

SIAN AMERICAN ARTISTS D

npiled by ALAN LAU and KAZUKO NAKANE for the ARCHIVES OF AMERICAN ART / SMITHSONIAN INSTITUTION

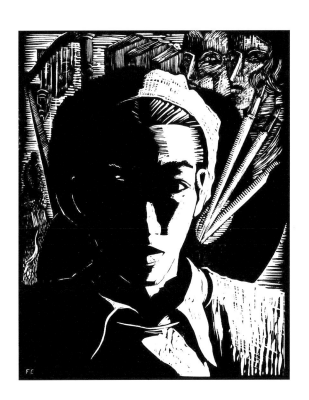

THIS CATALOG WAS PUBLISHED IN CONJUNCTION WITH AN EXHIBITION ORGANIZED
BY THE WING LUKE ASIAN MUSEUM SEPTEMBER 9, 1994 THROUGH JANUARY 15, 1995

THE SECOND PART OF THIS PUBLICATION IS THE DIRECTORY OF ASIAN AMERICAN ARTISTS IN WASHINGTON AND OREGON
PRODUCED BY THE ARCHIVES OF AMERICAN ART/SMITHSONIAN INSTITUTION

Printed in the United States of America

Designed by Paula Onodera Wong and Victor Kubo
Photography of artwork by Paul Macapia

About the cover: Art work by Fay Chong, Self Portrait, ca. 1930s, linoleum block print, collection of Marshall and Helen Hatch.

Photographs by Koike and Kunishige courtesy of Special Collections Division, University of Washington Libraries.

Photographs by Matsura courtesy of Okanogan County Historical Museum.

Library of Congress Cataloging-in-Publication Data

They painted from their hearts: pioneer Asian American Artists /
 edited by Mayumi Tsutakawa. Directory of Asian American artists in
 Washington and Oregon / Archives of American Art / Smithsonian
 Institution.
 p. cm.
 Published on the occasion of an exhibition organized by the Wing
 Luke Asian Museum, Sept. 9, 1994-Jan. 15, 1995.
 ISBN 0-295-97430-3 :
 1. Asian American Art--Northwest. Pacific--Exhibitions. 2. Art,
 Modern--20th century--Northwest, Pacific--Exhibitions. 3. Photogra-
 phy, Artistic--Northwest, Pacific--Exhibitions. 4. Asian American
 artists--Northwest, Pacific--Biography--Dictionaries.
 I. Tsutakawa, Mayumi. II. Wing Luke Asian Museum (Seattle,
 Washington) III. Archives of American Art. IV. Title: Directory of Asian
 American artists in Washington and Oregon.
 N6528. T54 1994
 759.195'089' 95--dc20 94-36755
 CIP

Wing Luke Asian Museum
407-7th Avenue South
Seattle, Washington 98104
(206) 623-5124

Table of Contents

Foreword

BY RON CHEW, Director, Wing Luke Asian Museum

The mission of the Wing Luke Asian Museum, since its inception in 1966, has been to rediscover, record and tell the story of Asian Pacific Americans in Washington State.

In the early years of this history, financial hardship—the inevitable burden borne by the immigrants and the generation bred in the era before World War II—forced most Asian Pacific Americans to focus on raw survival rather than creative pursuits of the heart. But each generation turns out its share of artists, no matter how few the nurturing influences or how harsh the conditions for expression. Chinese, Japanese, Korean and Filipino artists, though few in number at first, nevertheless found the time and means to create. They left behind a magnificent trail of works, some newly discovered in recent years, others reinterpreted for the quality of workmanship or their documentary value.

Since the Civil Rights Movement of the 1960s, a younger generation of Asian Pacific American artists and others working in the cultural realm have searched for sources of inspiration. They have turned to individual artists who paved the way for them one and two generations earlier. Embracing these pioneer artists and their works with new understanding has helped to re-illuminate the Asian Pacific American story and the overall heritage of the Pacific Northwest. Artists can express—in ways historians and academicians cannot—the soul of a community: how people see themselves and the world around them. This book, *They Painted From Their Hearts: Pioneer Asian American Artists*, is a rediscovery and celebration of these Asian Pacific Americans who were our first generation of artists. Like Asian Pacific American pioneers in other fields of creative endeavor, many were neglected, misunderstood and unappreciated. Some achieved fame in their time; others died in obscurity. With this book, we re-enter their world and explore both their collective influences and their rich individual visions.

Acknowledgements and Lenders to the Exhibition

With deep appreciation, we thank the major contributors to the exhibition, "They Painted From Their Hearts: Pioneer Asian American Artists":

CORPORATE
PRIME SPONSOR
SAFECO

MAJOR SPONSOR
THE BOEING COMPANY
THE ALLEN CHARITABLE FOUNDATION FOR THE ARTS

SPONSORS
HUGH AND JANE FERGUSON FOUNDATION
KREIELSHEIMER FOUNDATION
MICROSOFT CORPORATION
NESHOLM FAMILY FOUNDATION
NORDSTROM
PONCHO
SMITHSONIAN INSTITUTION, ARCHIVES OF AMERICAN ART
WASHINGTON MUTUAL SAVINGS BANK FOUNDATION
YUEN LUI STUDIOS

INDIVIDUAL
BENEFACTORS
JOHN AND MARY ROBINSON
ELLEN FERGUSON
MARSHALL AND HELEN HATCH
WAH AND MAY LUI
GEORGE AND AYAME TSUTAKAWA

PATRONS
ALBERT AND AUDREY KERRY
RICH AND DIANE SUGIMURA
BRIAN D. WONG
MAYUMI TSUTAKAWA
DWIGHT IMANAKA
DWIGHT AND CYNTHIA CHAN IMANAKA
HONGKONG AND SHANGHAI BANKING CORP.
BOB AND MARIAN OHASHI
HENRY AND RUTH TRUBNER
SHARON ROSE ANDERSON
ANDREW AND MARY C. CHINN

KIKUYO TAKAYOSHI
JON AND BOBBE BRIDGE
ROBERT AND CAROL GIVENS
JOHN AND LILLIAN MATSUDAIRA
MARY G. NEILL
DEAN AND GLORIA LUNG WAKAYAMA
AUSTREBERTA LAIGO
S. JAMES ARIMA
ARIMA FAMILY
BARBARA GRAHAM BARKER
SUZANNE EDISON
ALVIN AND RUTH GOULD
ROSE HASHIMOTO
VERA ING
PRISCILLA CHONG JUE
MICHAEL KAN
MITS AND KAZZIE KATAYAMA
RICHARD AND HELEN KAY
ROLAND AND BERNADETTE KUMASAKA
ALAN KURIMURA
JUD MARQUARDT
PAUL MIZUKI
THEODORE AND CAROL NAKAMURA
BARBARA NILSON
LAWRENCE OSERAN AND CAROL STARIN
DAVID AND MARIANNE PATNODE
DIANA SILL
SID WHITE AND PAT MATHENY-WHITE
SARA WIENER
GLENN YORITA
MARY JEANNE LORD

DONORS
GEORGE AND SUSAN ABE
DON AND KAREN AKIRA
RUSSELL AOKI
RICK AND GEORGETTE BARTON
MARIA BATAYOLA
TERESITA BATAYOLA
SONO BEGERT
CAROL BENNETT
HAL BLUMBERG AND DIANE WAH
RON AND LESLIE TANAKA DENNY
HELEN GAMBLE
GEORGE AND RAY CAROL GRIFFIN
BARBARA GROSS
ANNE GOULD HAUBERG
GEORGE AND MARIE ISHII

CAROLYN KELLY
KATIE KIYONAGA
JIM AND JANI LINARDOS
JACKIE LUM
ANDREA MANO
CHARLENE MANO
STEPHANIE MANO
PAUL AND ROSALIND MAR
RICHARD MAR AND SUE TAOKA
EMILY BREGGER MARKS
KEMI NAKABAYASHI
JUDITH NIHEI
GEORGE AND BETTY NOMURA
ROSS AND AVA OHASHI
EILEEN OKADA
DENNIS AND SUSAN OKAMOTO
THERESA PAN
TOMMER PETERSON AND BETTY JO FLETT
JAMES POTTER
FRED ROBINSON
BOB AND SHARON TOMIKO SANTOS
BOB SHIMABUKURO AND ALICE ITO
MAI KHA SHUTT
DENNIS SU
BEN TAKAYOSHI
RON TAKEMURA AND SHARON SAKAMOTO
KATS AND TERRIE TANINO
SHOKICHI TOKITA
GAIL TREMBLAY
JOSEPH TRETHEWEY
JIM WALKER
ELIZABETH WILLIS
DIANA K. WONG
MOOI LIEN WONG
JAN YOSHIWARA
GERALD AND JUDIE ELFENDAHL
MARCI WING

And many thanks to the lenders of art works in the exhibition:

JAMES ARIMA
DAN ESKANAZI AND DIANE LEVEQUE
SHOKICHI TOKITA AND GORO TOKITA
GEORGE AND AYAME TSUTAKAWA
PRISCILLA CHONG JUE
ANDREW CHINN
FRANCES CHINN
MIEKO HADA AND KIKUYO TAKAYOSHI
JEAN YANG
JOHSEL NAMKUNG
IRENE NAMKUNG
ASTREBERTA LAIGO
DEBRA AND PETER RETTMAN
MARSHALL AND HELEN HATCH
JOHN MATSUDAIRA
OKANOGAN COUNTY HISTORICAL SOCIETY
SPECIAL COLLECTIONS DIVISION, UNIVERSITY OF WASHINGTON LIBRARIES

Introduction

BY MAYUMI TSUTAKAWA, Exhibition Curator

In 1980 Alan Lau and I, neophytes in the book publishing world, put our heads together and created the anthology *Turning Shadows Into Light: Art and Culture of the Northwest's Early Asian/Pacific Community.* Armed with an impressive article on early Japanese American photographers by Robert Monroe, we gathered a wide array of cultural expressions of our grandparents' and parents' early days. These ranged from the Filipino American boxing world to the restoration of the Nippon Kan Theatre to an exploratory article I wrote on the early Asian American artists of the Northwest: "They Painted From Their Hearts." Alan added fine contemporary poetry by Northwest writers such as Laureen Mar and Lawson Inada, evoking memories of the early days.

Fourteen years later, the Wing Luke Asian Museum has dedicated considerable resources to the full-scale production of an exhibition and catalog of the creative works of the early Asian American artists, set against the dramatic backdrop of the history of Asians in the Pacific Northwest.

The stories of these artists are fascinating and varied as are the tales of finding each of the pieces for the exhibition. Japanese Americans suddenly had to leave their homes upon evacuation in 1942. Many fine artworks were destroyed or stashed in a neighbor's basement. The paintings of Takuichi Fujii, painted in the 1930s, were discovered as a bundle of canvases sold at a flea market on Capitol Hill in the 1980s. Although some artists' paintings had been donated to the Seattle Art Museum before the war, most of the prewar paintings by Japanese Americans were brought out of basements or closets for this exhibition.

Of the eighteen artists in the exhibition, only six are still alive. So, the search for works by these artists brought me into contact with a number of families of the artists. I visited twelve of the families in Seattle, Kent and Bellevue.

I learned of stories surrounding each individual artist which were alternately humorous, inspiring and heartbreaking. In some cases, I found that the widows and children of the artists had the artworks stored archivally. In other cases, the pieces were as they had been left many years ago—stacked in dusty storage areas. In many cases, the families were thankful that the development of this exhibition and catalog would bring recognition to the artists.

Some of the works I researched in the Special Collections of the University of Washington and in the Okanogan County Historical Society in a remote part of Eastern Washington.

For the exhibition, we only had space to display two or three works by each artist, far fewer than I would have liked. I hope that other institutions pick up the idea and mount exhibitions by each of these artists in the future.

In this publication, I have attempted to provide both a backdrop and a description of the artists' lives and creative work. An essay about art in the Northwest was prepared by Martha Kingsbury. I have prepared an essay about the painters, and Kazuko Nakane has written about the artists. And I have included a contemporary artist's reflection on the meaning of the pioneer artists in an essay by Lucia Enriquez.

We are also privileged to co-publish the Directory of Asian American Artists, prepared through the Archives of American Art. This directory of more than one hundred artists provides an invaluable resource for students and scholars.

I wish to extend my sincere appreciation to all the artists and family members of the artists and the collectors for their cooperation in putting this exhibition together. I also owe a debt of gratitude to the staff members of institutions I worked with, such as Paul Karlstrom at the Archives of American Art/Smithsonian

Institution, Richard Engeman at the University of Washington Libraries and Marilyn Moses of the Okanogan County Historical Society.

Also, for their wise advice I wish to thank artist Alan Chong Lau, Barbara Johns of the Tacoma Art Museum, Rod Slemmons of the Seattle Art Museum, Margo Machida of the Asian/American Center at Queens College, Karin Higa of the Japanese American National Museum, John Braseth of Woodside/Braseth Gallery, Carolyn Staley of Carolyn Staley Fine Prints and Ayame and George Tsutakawa.

Furthermore, for helping me with all aspects of the catalog and exhibition, I am indebted to Ron Chew, Diane Narasaki, Charlene Mano and Ruth Vincent of Wing Luke Asian Museum; writers Kazuko Nakane, Martha Kingsbury and Lucia Enriquez; designers Paula Onodera Wong and Victor Kubo; copy editor David Takami; Paul Macapia, intrepid photographer, and to Michael Constans, dedicated handyman, without whose assistance I could not have completed *They Painted From Their Hearts*.

A Short Chronology

Asian Pacific American Immigration and Relevant Legislation

1860s	First Chinese laborers come to Washington Territory.
1878	Washington Territory achieves statehood.
1882	Chinese Exclusion Act bans immigration of Chinese laborers.
1888	Scott Act bars Chinese laborers from returning to the U.S.
1886	Washington State Legislature approves Alien Land Law to bar Asians from owning land.
1890s	First Japanese laborers arrive in the Northwest.
1892	Geary Act extends Chinese Exclusion Act for ten more years.
1904	Chinese laborers excluded from immigration indefinitely.
1900s	First Filipino students and first Filipino, Korean and South Asian laborers come to Washington State.
1907-8	Gentlemen's Agreement restricts immigration of Japanese laborers; "picture brides" are allowable.
1917	Immigration Act of 1917 bars immigration of South Asian laborers and prevents South Asians from bringing over their wives.
1921	Legislature passes another Alien Land Law to prevent Asians from owning or leasing land.
1924	Immigration Act of 1924 excludes all Asian immigrants except Filipinos as "aliens ineligible to citizenship." Targeted at Japanese Americans, it also prevents Chinese women from rejoining their husbands in America.
1934	Tydings-McDuffie Act limits Filipino immigration to 50 per year for U.S.
1937	State amends Alien Land Law to prevent Filipinos from owning land.
1942	Federal Executive Order 9066 authorizes ouster of over 120,000 Japanese Americans from homes on the West Coast.
1945	Chinese and Filipino women come under the War Brides Act.
1950s	Guamanians and Samoans begin to arrive.
1952	Walter-McCarran Act passed; all Asian races became eligible for immigration and citizenship again.
1953	Korean War ends, Korean war brides and students begin to arrive.
1965	Immigration Act of 1965 allows increasing numbers of Chinese, Filipinos, Koreans, South Asians and Southeast Asians to come.
1970s	Refugees from Vietnam, Laos and Cambodia and immigrants from other countries of Southeast Asia come to the U.S.

Checklist of the Exhibition

Sumio Arima
Boats in the Harbor
1923
Oil on canvas
Collection of the Arima
Family

Sumio Arima
Nude
1923
Oil on canvas
Collection of the Arima
Family

Takuichi Fujii
Bridge
ca. 1930s
Oil on canvas
Collection of Dan
Eskenazi and Diane
Leveque

Takuichi Fujii
Yesler
ca. 1930s
Oil on canvas
Collection of Dan
Eskenazi and Diane
Leveque

Takuichi Fujii
Still Life
ca. 1930s
Oil on canvas
Collection of Dan
Eskenazi and Diane
Leveque

Kenjiro Nomura
Harbor
1953
Oil on board
Collection of George and
Betty Nomura

Kenjiro Nomura
Renton Bridge
1938
Oil on canvas
Collection of George and
Betty Nomura

Kenjiro Nomura
Barn
ca. 1930s
Oil on canvas
Collection of George and
Betty Nomura

Kamekichi Tokita
Self Portrait
ca. 1930s
Oil on canvas
Collection of the Tokita
Family

Kamekichi Tokita
Texaco
ca. 1947
Oil on canvas
Collection of the Tokita
Family

Kamekichi Tokita
Hunt, Idaho
ca. 1942
Oil on canvas
Collection of the Tokita
Family

Shiro Miyazaki
Sunflowers
ca. 1930s
Oil on canvas
Collection of George
Tsutakawa

Shiro Miyazaki
Still Life
ca. 1930s
Oil on canvas
Collection of George
Tsutakawa

Fay Chong
Power Lines
1958
Watercolor
Collection of Priscilla
Chong Jue

Fay Chong
Uncle Post's Warehouse
1947
Watercolor
Collection of Priscilla
Chong Jue

Andrew Chinn
Returning Sail
1941
Watercolor
Collection of the Artist

Andrew Chinn
Seward Park
ca. 1950s
Watercolor
Collection of the Artist

Lawrence Chinn
Portrait
ca. 1950s
Oil on canvas
Collection of Frances
Chinn

Lawrence Chinn
Landscape
ca. 1950s
Watercolor
Collection of Francis
Chinn

Val Laigo
Dilemma of the Atom
1953
Oil on canvas
Collection of Astreberta
Laigo

Val Laigo
Circus Piece
1958
Oil on canvas
Collection of Astreberta
Laigo

Paul Horiuchi
Wyoming Winter
1949
Watercolor
Anonymous Collection

Paul Horiuchi
Writing From the Past
ca. 1950s
Mixed media
Collection of Debra and
Peter Rettman

John Matsudaira
Tombo Tsuri
1953
Oil on canvas
Collection of the Artist

John Matsudaira
Prelude to Winter
1960
Oil on canvas
Collection of the Artist

George Tsutakawa
Dancers
1947
Oil on canvas
Collection of the Artist

George Tsutakawa
Rescue # 1
1958
Oil on canvas
Collection of the Artist

Frank Kunishige
Vanities
ca. 1926
B & W photograph
Collection of Special
Collections Division,
University of Washington
Libraries

Henry Takayoshi
Silent Sign
ca. 1950s
B & W photograph
Collection of Mieko Hada

Frank Kunishige
Dancer
ca. 1927
B & W photograph
Collection of Special
Collections Division,
University of Washington
Libraries

Kyo Koike
Girl with Violin
ca. 1920s
B & W photograph
Collection of Special
Collections Division,
University of Washington
Libraries

Kyo Koike
Sea of Clouds
ca. 1920s
B & W photograph
Collection of Special
Collections Division,
University of Washington
Libraries

Frank Matsura
Colville Woman
ca. 1910
B & W photograph
(Original negative is in
the Collection of the
Okanogan Historical
Society)

Frank Matsura
Waterfront
ca. 1901
B & W photograph
(Original negative is in
the Collection of the
Okanogan Historical
Society)

Henry Takayoshi
Untitled
ca. 1950s
B & W photograph
Collection of Mieko
Hada

Chao-Chen Yang
Apprehension
1951
Color photograph
Collection of Jean Yang

Chao-Chen Yang
3 Men in Chicago
1938
B & W photograph
Collection of Jean Yang

Chao-Chen Yang
Paris Streetsweepers
1956
Color photograph
Collection of Jean Yang

Johsel Namkung
916 Jackson St.
1957
Color photograph
Collection of the Artist

Johsel Namkung
California Coast
ca. 1950s
B & W photograph
Collection of the Artist

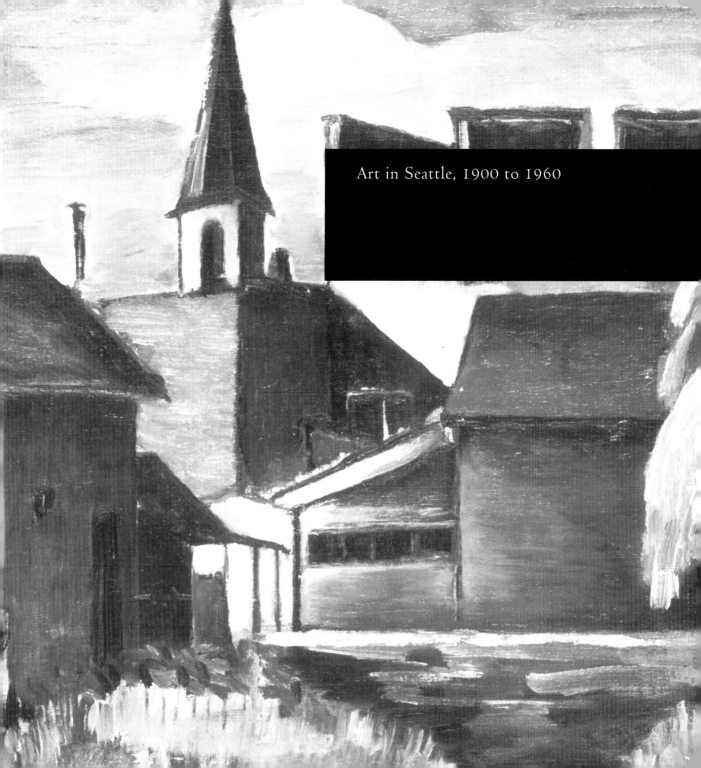

Art in Seattle, 1900 to 1960

Art in Seattle, 1900-1960

BY MARTHA KINGSBURY

IN 1900, SEATTLE WAS A RAW TOWN in a remote corner of the United States, just coming into a sense of itself. It had no galleries or museums where art was shown on a regular basis, no established network of artists and art lovers, no cultural identity beyond being an outpost on the celebrity tour circuit and a fledgling source of vaudeville shows for the Coast and Alaska. Within a half century, the area gave rise to art of vigor and diversity, including an artists' group of national and international renown.

Early travelers and immigrants depicted the region's mountains, and occasionally portraits of each other. Settlers like Emily Inez Denny and Harriet Foster Beecher painted delicate naturalistic views of the forests and shores around Seattle. Soon, professionally trained painters arrived from the East, including Edgar Forkner, Paul Gustin and Kathleen Houlahan. Abby Williams Hill in nearby Tacoma was an example of the self-invented cultural trailblazing of these early artists; she had contacts with the Great Northern and Northern Pacific railways to paint the scenic grandeur along their western routes. This made possible long summer camping trips with her children, when she worked on the contracted paintings, which she exhibited at a number of World Fairs.

A Seattle Fine Arts Society was established in 1908 and soon sponsored traveling loan shows and annual exhibitions of local artists. Its first public exhibition consisted of over four hundred Japanese prints loaned by sixty-three Seattle residents. Mrs. T. Koitabashi gave a demonstration of Japanese flower arranging during the exhibition. The Fine Arts Society helped other organizations initiate a permanent framework for the arts in Seattle. In 1909, the city hosted a fair it named the Alaska-Yukon-Pacific Exposition. Seattle thus announced itself to the world as the pivotal

point linking the United States with the distant reaches of the North and Far East. The fair included exhibitions of historical and contemporary art.

While artists struggled to make a future for themselves, art also served nostalgic purposes. The first public art commissioned in Seattle was a bronze figure of Chief Seattle, sculpted in 1907 by James Wehn. Throughout the United States there was a strong sense of Indian culture as something passing away. Seattle residents collected Native American artifacts early enough to send some to the 1893 Columbian Exhibition in Chicago and to include many in the 1909 A.Y.P. Exposition. The city's first artist of renown was undoubtably Edward Curtis, whose poetic photographs depicted Native Americans in twilight stillness, evocative of quiet respect, reverie and nostalgia for a lost past.

Nostalgia aside, the cultural possibilities of the area were complex. Northwest Coast Native Americans were less nomadic than inland tribes; groups were deeply rooted around Puget Sound. They were not so drastically displaced as many of the Eastern Washington tribes, and remained part of the life of the area. Trade opportunities and railroad construction had drawn immigrants from China and Japan. There was a double edge to the East Coast settlers honoring these Native American and Asian cultures with esteem and nostalgia, for they tended to assume that these cultures were past, and that the future lay with their own artistic practices and museums. During the early twentieth century, increasing restrictions on Asians limited immigration, citizenship, and property ownership; while at roughly the same time, Native Americans were restricted not only regarding land and civic rights, but their Potlatch Ceremony—fundamental to their social structure and the purpose and meaning of many of their finest

"Seattle announced itself to the world as the pivotal point linking the United States with the distant reaches of the Far East"

art objects—was prohibited. Only decades later were the legal rights and the viability and value of these artistic cultures gradually restored.

 Seattle artists continued to describe the beauties of the Northwest terrain. But after World War I, painters and sculptors were increasingly drawn to the new freedoms of emotional and interpretative art forms. Exciting visual rhythms and pictorial structures were invented in Europe in the early twentieth century—styles that critics were quick to label Fauvism, Cubism, Expressionism; and others that artists themselves called Dadaism, Surrealism. The modernist climate favored experimentation in art, not meticulous verisimilitude, and these challenging attitudes gradually gained ground in Seattle, too. Many modernist painters came to the area between the wars, including Malcolm Roberts, Rudolph Zallinger, Margaret and Peter Camfferman, and Margaret Tomkins.

 With many more artists working and exhibiting, some artists' groups focused on a particular medium. Among photography societies, the Seattle Camera Club was especially vigorous in the late twenties. It sponsored meetings and exhibitions, and an ambitious publication, *Notan*, and its participants were internationally successful. Leading members like Frank Kunishige and Dr. Kyo Koike sought to make photography a fully expressive art, not simply a documentary technology.

 The Northwest Printmakers, organized in 1928, solicited members from all over the United States and held regular exhibitions. Prints were an area in which the heritage of Asian art was indirectly present in Seattle. Ambrose Patterson, first head of the University of Washington art program, had not only exhibited with the radical Fauvist painters in Paris around 1905; he subsequently executed exquisite prints

in the most refined and nuanced manner of Japanese print influences. Also, Helen Rhodes and Walter Isaacs, who joined the staff there about the same time, 1920, brought influences of the design theories of Arthur Dow. Dow's widely admired esthetic system was based on the structural patterns of East Asian painting and Japanese prints. Throughout the thirties, printmaking was a vigorous medium in the Northwest, indirectly drawing visual strength from both Asian and Western heritages.

By the early thirties, Seattle had established permanent sites for seeing and making art. The Cornish School, founded in 1914, expanded into substantial new quarters in 1921, about the time the University art program got under way. Cornish flourished as a focus for integrated creative arts, and brought innovative artists to the area, including Mark Tobey in the early twenties and later John Cage. The city and University received a boost from Horace C. Henry's gift of his paintings—mostly nineteenth century landscapes—and a gallery to house them on campus. In 1933, the Seattle Art Museum opened in Volunteer Park, perched high above the city's commerce, harbor, and outlying bay and islands. The Museum's elegantly reticent Art Deco building was designed by Carl Gould, and extensive collections were given by Mrs. Eugene Fuller and her son Dr. Richard E. Fuller, who continued for decades to set its policy. Among his firm loyalties were support of contemporary local artists, and a deep love, shared with his mother, for the fine arts of Asia, which formed the core of their collections.

Art museums, art schools, and artists groups were scarcely established in Seattle when the Great Depression brought prosperity to a grinding halt. The sophisticated developments of European modernism had just established a toehold when American art turned emphatically toward local subjects and clear representational

styles. For these, it was believed, could best address the social and political concerns generated by a collapsing economy. While Americans regarded certain aspects of visual culture as delightful escapes from crisis (movies, for example, or streamlined modernist product design), the pictorial arts and sculpture had become, in everyone's minds, a serious undertaking involving cultural values. The young museums and art programs struggled against economic hardship; and though not all artists and groups flourished, the need for art was felt as never before. This was apparent when the federal relief programs decided to help artists along with other American workers. From 1933 through the early forties, government programs extended modest financial aid and implicit legitimacy to practicing artists. The Seattle painter Bill Cumming, in his memoirs of those days, has spoken for artists all over the country, recalling vividly how much it meant that art was protected through hard times as an integral part of the social fabric.

The Depression was a time of informal associations, when esthetic differences were overcome by the practical difficulties everyone faced. A cluster of Seattle painters, calling themselves The Group of Twelve, exemplified the spirited devotion of artists pushing on through rough times. In 1937, they managed a modest publication of their paintings and brief statements in a local press. The Group included independent artists and artist-teachers; local natives and newcomers; three Japanese; and three women members. Their paintings and statements varied. Some, like Kenneth Callahan and Ambrose Patterson, derived much from European expression to interpret the light and flora of the Northwest, while others, like Kamekichi Tokita and Kenjiro Nomura, were closer to social realism in their paintings of the dusty side streets of Seattle.

Economic hardship encouraged modest art works, like prints or private paintings, yet the government's commitment to art encouraged the opposite,

and public artworks achieved new prominence. Mural projects carried out by local artists for federally funded buildings such as post offices were widely known and liked (more than a half dozen were created in western Washington). The 1938 *Portal of the Pacific* highway tunnel entrance was a stunning collaboration between sculptor James Fitzgerald and engineers. Fitzgerald's reliefs, based on Northwest Indian art, hold their own against the powerfully shadowed concentric curves of the tunnel entries and the scale of the hillside. Respect for art's power and meaning lingered after the Depression and spread beyond the narrower circles of artists and patrons into increased education programs in high schools for example, or into the Seattle Union Hall of the Shipscalers, Drydock and Boatworkers Union. In 1945, the union commissioned a mural from Pablo O'Higgins, who like several Seattle artists was impressed by the great mural programs of Mexico during the late 1920s. O'Higgins' work, seven by almost sixty feet, depicted leaders, soldiers, and workers of all races, united in the struggle for justice.

But during World War II and the Cold War such public aspirations for art receded. Public art came to seem, temporarily, like propaganda. Audiences and artists themselves were increasingly drawn toward deeply private works, expressions of fierce intensity and moral authenticity. The pessimism generated by the war and its aftermath gave rise to introspective, melancholy, or violent paintings. It was then, through the forties and early fifties, that the paintings of Mark Tobey, Morris Graves, Kenneth Callahan and other Seattle area painters became widely known and admired as "Northwest School." These artists lacked a "school's" manifestos, master-students relations, or strict stylistic unity. They might better have been seen as united in a "sensibility," for they did share predilections for works of small-scale intimacy,

dense structures, muted color, and delicate materials, often water-based media on paper instead of oil on canvas. Tobey, Graves, and Callahan established their characteristic manners around 1940 and, over the next fifteen years, other artists became closely associated with the group image—Guy Anderson, Paul Horiuchi, George Tsutakawa, Margaret Tomkins.

Tobey's work was the most challenging nonrepresentational painting Seattle had ever produced. His paintings consisted of rhythmically looping tangles of pale lines, or patterned wiggles of broken gestures. They were described as a "white writing," to be understood by analogy with Asian calligraphy. Graves often painted birds or small animals, in eerie dreamlike realms of dusk, and these too were related to Chinese and Japanese art. Tobey, Graves and others of the "Northwest School" made use of European traditions and international modernism. But it was the Asian qualities that seemed most fascinating and desirable to many viewers both locally and on the East Coast and in Europe.

After the War, Americans became increasingly fascinated with the Far East, Zen and Mysticism. It was as a "mystical" and "oriental" group that these Seattle artists became widely known. There was unacknowledged irony in this, as their rise to fame had accompanied the wartime suspicion of West Coast Asian Americans, and in particular the disintegration of Japanese American communities. While the Far Eastern artworks in the Seattle Art Museum had played a role in these painters' sensibility, so too had their associations, in the Thirties, with the Asian American photographers and painters, deeply rooted in Seattle's Asian American community. It was a rich reciprocity that the War cruelly disrupted, a genuine empathy that artists had achieved and that their art sustained.

"After the war,

Americans became

increasingly fascinated

with the Far East,

Zen, and

mysticism"

Through the fifties, the "Orientalism" of Seattle art dominated many minds. The Seattle Art Museum was enriched by Asian treasures acquired under the direction of Sherman Lee. The fame of Morris Graves and Mark Tobey burgeoned, culminating in 1961 in Tobey's large Paris Exhibition at the Musée des Arts Decoratifs and his 1962 retrospective New York's Museum of Modern Art. Asian American artists came into mature styles and increasing recognition—George Tsutakawa, Paul Horiuchi.

But that "oriental" image was increasingly misleading, for Seattle artists in the fifties were determinedly individualistic. Tobey and Graves left the Northwest, and many of their associates moved to remote areas. Asian Americans felt as free as anyone else to chose the style that best suited their purpose—for example, Frank Okada as much as William Ivey, were notable postwar abstractionists. Modern European masters' works were brought to Seattle through Zoe Dusanne's gallery, begun in the late forties; and in the fifties Dusanne supported local modernist artists, including Asian Americans. Soon other galleries appeared—Otto Seligman's, Gordon Woodside's. Artists also found opportunities to exhibit at the Annual Western Washington Fair in nearby Puyallup and eventually in other local fairs. Some Northwest artists left for Europe to study after the War—Spencer Mosely with Leger, for example. Others like Alden Mason were deeply drawn to nature, translating it into striking expressive forms. The heritages of Mexico and Northwest Indians appeared in the sculpture by James Washington, Jr., prints by Helmi Juvonen.

In 1962, Seattle held another World's Fair. Under the shadow of its Space Needle, the city took another look at art. There was a substantial section called Northwest Art Today, as well as recent international art, and contemporary crafts.

An urge toward public art began to make itself felt again, a returning trust in art's meanings and beauty. For the Fairground and the new Seattle Public Library building of 1960, many permanent artworks were commissioned. Since then, the increasingly vigorous world of art in Seattle has grown steadily, through a widening public for private arts, and more personally accessible public arts.

Martha Kingsbury is a professor of art history at the University of Washington with a focus on nineteenth and twentieth Century American art. She has published essays about Pacific Northwest art history in *Art of the Thirties* (Henry Art Gallery, 1972), *Art of the Pacific Northwest* (Smithsonian Institution, 1974), *Northwest Traditions* (Seattle Art Museum, 1978) and *Celebrating Washington's Art* (Washington State Centennial Commission, 1989). She also has written individual publications on artists George Tsutakawa and Helmi Juvonen.

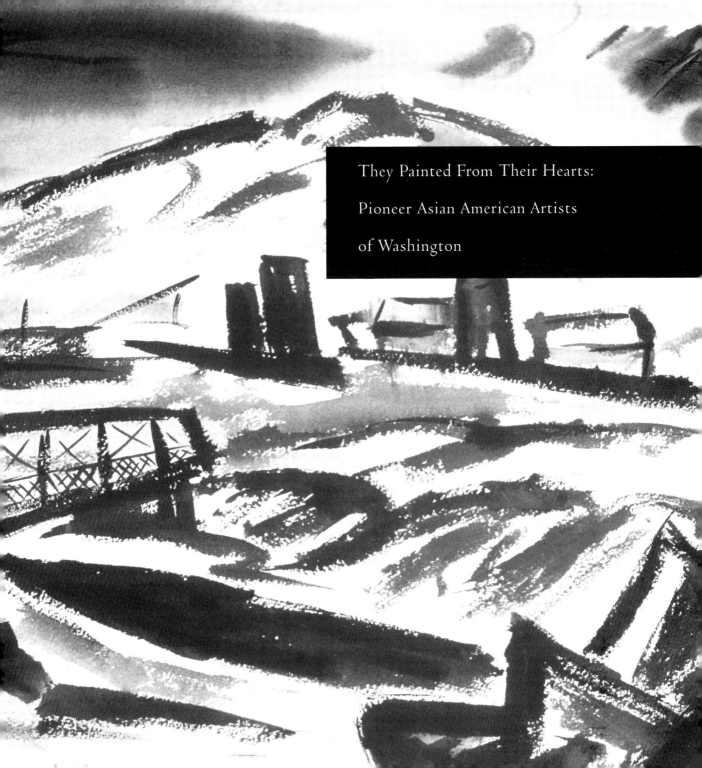

They Painted From Their Hearts:

Pioneer Asian American Artists

of Washington

They Painted From Their Hearts:
Pioneer Asian American Artists of Washington

BY MAYUMI TSUTAKAWA

The ASIAN AMERICAN PAINTERS OF WASHINGTON in the half century from 1910 to 1960 laid a foundation of work which reflected both the major artistic trends of America and the historic events that influenced the artists' lives and that of their communities. Undoubtedly, the marginalization of the ethnic communities, combined with the Great Depression's undeniable negative impact on Seattle, left their mark. But these artists were able to transcend economic difficulties and excelled within the artistic community of the Pacific Northwest.

Japanese American, Chinese American and Filipino American artists were active members of their communities and sometimes met to work on their art and exhibits together in International District storefront spaces and in notable Seattle galleries. In the case of the Japanese Americans, one can only speculate as to how their talents could have developed were it not for the interruptions of incarceration in World War II concentration camps.

I. Social Realist Painters

In the prewar period, the Asian American community was characterized by its social isolation and a relatively low economic status. Due to the waves of Asian Exclusion Laws and Alien Land Laws, first Hawaiians, then Chinese, South Asians, Japanese and Filipinos were restricted from immigration and land ownership. Single women were prevented from immigrating, thus reducing marriage opportunities for the largely male Asian labor force in the United States and slowing the growth of a native-born Asian population.

Moreover, after the early period of railroad and logging work, many of the Asians set to work supporting the Asian communities in the Northwest and worked in the trades and service industries. It was not until the second generation Asians attended college and reached adulthood that the range of Asian American occupations would diversify. For example, in 1935 the largest majority of the Japanese population worked in domestic service and hotels and groceries. (Miyamoto, 1984).

The Japanese painters who broke with traditional Asian techniques were Social Realists, drawing upon the American Scene Painting genre, but often emulating the Ash Can School which had emerged in America before World War I. All born in Japan, many of these painters benefited from study of Japanese calligraphic and painting techniques in their childhood and teen years. They were mostly self-taught, but their works show excellent technique and strong composition.

Takuichi Fujii (born 1892), who was born in Hiroshima, pursued Realist scene painting, presenting strong compositions of Seattle scenes and some still life paintings. Very little information exists about Fujii, except that he worked with the painters Tokita and Nomura, as well as joining the Group of Twelve, a salon of notable Seattle painters in 1937. His work was included in the group's illustrated publication that year. Before the war, he ran a flower shop in central Seattle. With his family, he was interned in the wartime relocation camp in Hunt, Idaho, and soon after the war, moved on to Chicago. According to letters from his daughter to friends during wartime, Fujii became depressed and had little desire to paint after entering the camp, but did participate in at least one art show there.

Sumio Arima (1901-1987), born the son of a Presbyterian

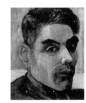

TAKUICHI FUJII
SELF PORTRAIT

minister in Tokyo, took a different path. After coming to Seattle in 1918, he spent some years at Broadway High School, then graduated and went to New York to pursue an art career. He studied for two years at the New York Art Institute under the noted painter John French Sloan and produced some Expressionist figurative work. But giving up his art study, he returned to Seattle to work on his father's Japanese and English language newspaper, the *North American Times.* Though he continued an interest in art and was an avid photographer, eventually he took over the paper as publisher. For these activities, he was among the first Japanese in the community rounded up by the FBI at the war's outbreak under suspicion of spying for Japan. After the war, he quit his art career and, following a short stint as editor of the Japanese community's *North American Post,* he went into the dry-cleaning business.

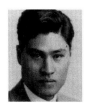

SUMIO ARIMA

Shiro Miyazaki (1910-1940) was born in Nara and came to Seattle after attending the California School of Fine Arts in San Francisco. A close friend of artist George Tsutakawa, he showed strong promise as a painter. His works evoked a feeling of the Post Impressionists such as Cezanne and Van Gogh. Rejecting the path of continuing his father's Japanese newspaper business, Miyazaki became an active labor organizer and was disinherited by his family. He went back to California to work in the agricultural labor movement and died of an illness at the age of thirty, still unrecognized by his family.

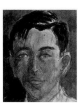

SHIRO MIYAZAKI
PORTRAIT BY GEORGE TSUTAKAWA

Among the Japanese painters, Kamekichi Tokita (1897-1948) and Kenjiro Nomura (1896-1956) exemplify artists who worked in the Japanese community while at the same time achieving recognition from the emerging major art scene of the Pacific Northwest. Tokita is noted for his strong Ash Can School depictions of the underbelly of Seattle in the thirties. Nomura evolved his style of Realist Scene

painting of the thirties to a Kandinsky-like non-objective Expressionist style in the fifties.

Kamekichi Tokita was born in Shizuoka and attended college in Japan. He worked in Manchuria for two years before coming to Seattle in the 1920s. He opened the Noto Sign Company with Kenjiro Nomura in the International District. At first, Tokita learned his creative painting technique from Nomura, and the two actively pursued their art, both receiving an invitation to exhibit at Henry Art Gallery at the University of Washington in 1928. Tokita went on to show his work at major exhibits in Seattle, Oakland, San Francisco, Portland and New York. Noted painters Kenneth Callahan and Mark Tobey were friends and mentors. Tokita was one of the federal Public Works Projects artists in Washington. Foreshadowing the need for Japanese Americans to rid themselves of precious possessions, he donated several of his paintings to the Seattle Art Museum in the early thirties.

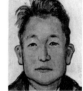

When the Second World War broke out, Tokita was interned with his family at Camp Minidoka in Hunt, Idaho, where he contracted a serious illness. He produced few paintings during the internment and after the war he took up the operation of a small hotel, as he and his wife had done before they left for Minidoka. He died shortly after the war.

Kenjiro Nomura was born in Gifu, the son of a tailor. His father had made money during the Alaska Gold Rush before returning to Gifu to marry. Kenjiro Nomura came to Tacoma when his family moved back to the United States in 1907. He moved to Seattle by himself after his family returned once again to Japan when he was 16. Nomura worked in salmon canneries and delivered dry goods. In 1921, he began to study with the noted Dutch artist Fokko Tadama, who had set up a school in Seattle. Learning the sign painting business, Nomura and Tokita worked together

and sketched together. Nomura began to show his work in California, New York and at the Seattle Art Museum. He won several prizes and was part of an exhibit at the Museum of Modern Art in 1933. He also worked for the federal Public Works Project.

KENJIRO NOMURA

Nomura and his family also were interned at Camp Minidoka during the war. He made many sketches during camp, not intending them for exhibition. Following the war, he had little desire to paint, but was strongly encouraged by painter Paul Horiuchi. Nomura experimented with abstraction and he exhibited with Horiuchi, Tsutakawa and John Matsudaira at the Zoe Dusanne Gallery, the first contemporary gallery in Seattle. One of his paintings was shown at the Sao Paulo Bienale. But Nomura continued to support himself by pressing clothes in a garment factory. Although he finally found work to his liking in a frame shop, he died shortly thereafter, in 1956, following complications from minor surgery.

II. Chinese Art Club

The Chinese American painters' work was characterized as drawing upon traditional Chinese painting styles, but presenting Seattle cityscapes and eventually amalgamating contemporary Western abstract techniques. One characteristically Chinese influence was that their paintings were usually accompanied by a Chinese calligraphic explanation and the artist's chop (seal). They worked from a studio in Seattle's Chinatown.

FAY CHONG
SELF PORTRAIT

Fay Chong (1912-1973) was born in Kwangtung and came to Seattle in 1920. He studied art at Broadway High School where he became close with noted painter Morris Graves and George Tsutakawa. He studied calligraphy on trips

back to China in 1929 and 1935. In the thirties, he studied with Hannah Jones and Leon Derbyshire and did work for the Public Works Project from 1938 to 1940. In 1936 Chong and Andrew Chinn founded the Chinese Art Club, a group of several painters who were visited often by noted painters Bill Cumming and Guy Anderson. Chong was a student of noted painter Mark Tobey from 1939 to the mid fifties. He showed his work in solo shows at the Seattle Art Museum in 1942 and 1957, in California, Oregon and in New York. He worked as an illustrator for The Boeing Co. during the War. He continued his education, earning his M.A. at the University of Washington in 1971 and teaching art in this area. He and his artist wife Priscilla Hwang showed their work together for many years.

ANDREW CHINN

Andrew Chinn (b. 1915) was born in Seattle but his early education was in Kwangtung Province. He returned to Seattle in 1933 and graduated from Franklin High School. He attended the University of Washington and studied with Walter Isaacs, Ray Hill and Ruth Penington. He was a founder of the Chinese Art Club with Chong and Yippe Eng. Chinn worked in the Federal Arts Project and as a technical illustrator at Sand Point Naval Base and Bremerton Navy Yard. He then went to work as an illustrator for The Boeing Co. until his retirement in 1978. He has taught Chinese style watercolor painting since 1945 and continues to teach a class at Seattle Central Community College.

Lawrence Chinn (1914-1994) was born in Kwangtung Province and studied art at the Chek Sheh Art Institute there. He later came to Seattle and attended Franklin High School. In 1935 he attended aviation school and became an aircraft engine mechanic. Chinn was an active member of the Chinese Art Club, working in Chinatown for many years. In his later years, he specialized in designing Chinese style

LAWRENCE CHINN

kites and became an active member of the Washington Kitefliers Association.

III. Abstractionist Painters

After World War II, Asian American painters turned their focus from depicting scenes around them to the inward exploration of Abstract Expressionism which had strongly taken hold in American painting in the dozen years following World War II. Particularly in the Northwest, the experimenters in this genre delved into and emulated Asian painting styles, notably Zen painting which combined the bold quick painterly strokes of sumi technique and often Chinese calligraphy characters. The influence of Mark Tobey on these young artists was profound as he nurtured and encouraged their interest in Asian art. They all actively exhibited their work and often won prizes at the Seattle Art Museum's Northwest Annual, the Western Washington Fair in Puyallup, International Exhibitions they organized in Chinatown (including artists such as James Washington, Jr.) and at the Bellevue Arts and Crafts Fair.

PAUL HORIUCHI

Paul Horiuchi (b. 1906) was born in Kawaguchi and studied brush painting there for three years. He moved to Wyoming in 1921 where he become friends with the transplanted New York artist Vince Campanella. After the difficult years of a transient lifestyle during World War II, he moved to Seattle with his family. He worked for some years in a body and fender shop. At the same time, he developed close friendships with Mark Tobey and the art and antique dealer James Takizaki, both of whom encouraged Horiuchi's study of Japanese arts. His painting style developed with the use of calligraphy, then adding collages of Japanese newspaper and mulberry

paper. Beginning in the mid-fifties Horiuchi began to exhibit his work nationally and internationally, with numerous solo exhibits in Seattle at the Zoe Dusanne Gallery, in New York, Los Angeles and Portland. He has been represented in group exhibits in Europe, Japan and at the Smithsonian Institution in 1974.

George Tsutakawa (b. 1910) was born in Seattle and raised in Fukuyama. He returned to Seattle by himself at the age of 18, determined to become an artist. He worked in a relative's import business and a grocery store, and attended Broadway High School, where he won a national high school art prize, the same year that his colleague Morris Graves did. Tsutakawa then attended the University of Washington, studying with Dudley Pratt and briefly with Alexander Archipenko. He finished his bachelor's degree in art before World War II, when he served in the U.S. Army Military Intelligence School. After the war, he finished his M.F.A. and began teaching art at the University of Washington until his retirement in 1976. He worked first in oil painting and wood block prints, then in wood and metal sculpture. He developed the fountain sculpture of fabricated bronze and completed seventy-five major commissions in the United States, Canada and Japan. With encouragement from Mark Tobey, he began to work in sumi painting in the sixties, exploring both abstract styles and subjects from nature. He has exhibited widely in the United States and Japan.

GEORGE TSUTAKAWA

John Matsudaira (b. 1922) was born in Seattle and lived in Kanazawa from 1928 to 1935. He served in World War II with the famed 442 Regimental Combat Team. After the War, he studied at the Burnley School of Art, learning from Jacob Elshin and Nick Damascus. He developed his abstract casein painting style and showed his work with Nomura, Horiuchi and Tsutakawa at the Zoe Dusanne Gallery in 1954. He worked as a graphic illustrator with The Boeing Co. for many years.

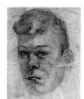

JOHN MATSUDAIRA
SELF PORTRAIT

Valeriano Montante Laigo (1930-92) was born in Naguilian, Philippines, and his family came to Seattle when he was an infant. He graduated from O'Dea High School and received his bachelor's degree in education from Seattle University in 1954. He went to Mexico City College for post-graduate work in 1956 and 1957 and there he met his wife Austreberta. Due to his ill health, they returned to Seattle just as he was producing a solo exhibit of his work in Mexico City. Laigo also worked as

VAL LAIGO IN HIS STUDIO PHOTO: BOB PETERSON

editorial artist for the Seattle Post-Intelligencer in 1952 and at The Boeing Co. as staff artist and art director from 1959 to 1963. He received his M.F.A. from the University of Washington in 1964 and taught art at Seattle University from 1965 to 1985. He exhibited his work extensively in the Seattle area. Laigo created three major murals: one for The

Boeing Co. in 1960, another for Seattle University in 1967 and a major outdoor work at José Rizal Park in Seattle in 1981. He is among the most noted Filipino American artists.

The Asian American painters were intensely prolific, combining influences of Asian and Western art. They contributed richly to the Pacific Northwest art scene during a period when Asians were isolated as an immigrant community. They laid a foundation for many other Asian American artists of considerable talent who followed them.

Sources

Miyamoto, S. Frank, *Social Solidarity Among the Japanese in Seattle,*
University of Washington Press, 1984
Directory of Asian American Artists in Washington and Oregon,
Archives of American Art, 1991
Kingsbury, Martha, *George Tsutakawa,* University of Washington Press, 1990
Interviews with the artists and their families, 1994

Mayumi Tsutakawa is an independent writer and editor. She has edited four anthologies of multicultural literature including *Turning Shadows Into Light* (Young Pine Press, 1982), and *Edge Walking on the Western Rim* (One Reel/Sasquatch, 1994).

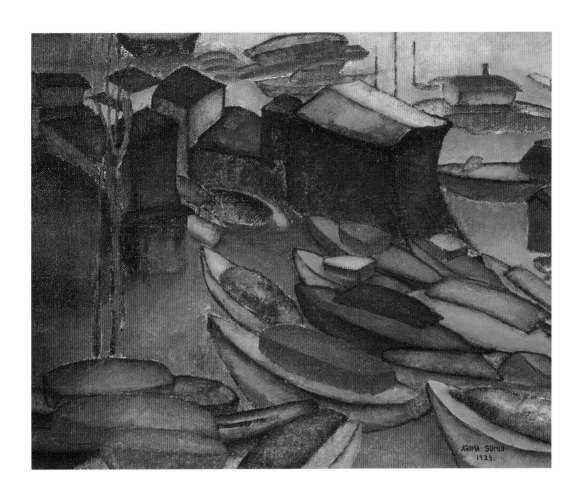

SUMIO ARIMA

———

Boats in the Harbor, 1923

Oil on canvas

Collection of the Arima Family

Photo by Paul Macapia

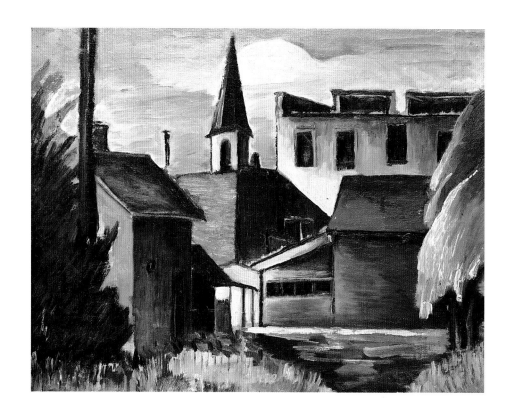

TAKUICHI FUJII

———————

Yesler, ca. 1930s

oil on canvas

Collection of Dan Eskenazi and Diane Leveque

Photo by Paul Macapia

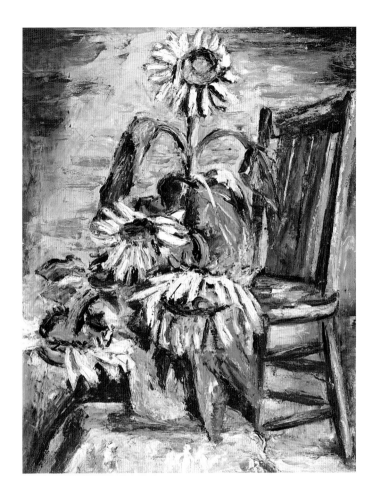

SHIRO MIYAZAKI

Sunflowers, ca. 1930s

Oil on canvas

Collection of George Tsutakawa

Photo by Paul Macapia

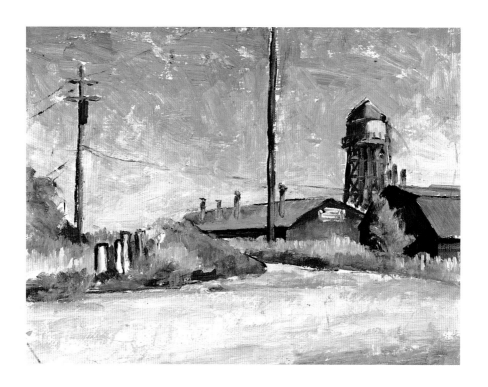

KAMEKICHI TOKITA

Hunt, Idaho, ca. 1942

Oil on canvas

Collection of the Tokita Family

Photo by Paul Macapia

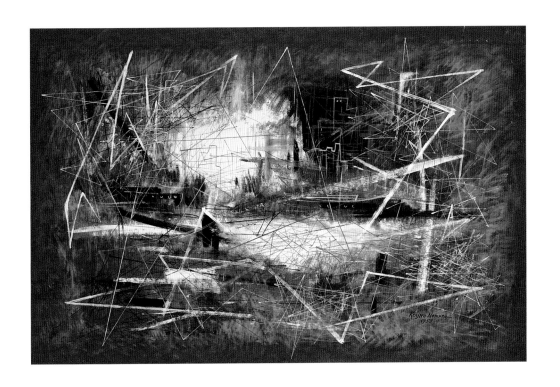

KENJIRO NOMURA

———

Harbor, 1953

Oil on board

Collection of George and Betty Nomura

Photo by Paul Macapia

FAY CHONG

———

Uncle Post's Warehouse, 1947

Watercolor

Collection of Priscilla Chong Jue

Photo by Paul Macapia

ANDREW CHINN

Seward Park, ca. 1950s

Watercolor

Collection of the Artist

Photo by Paul Macapia

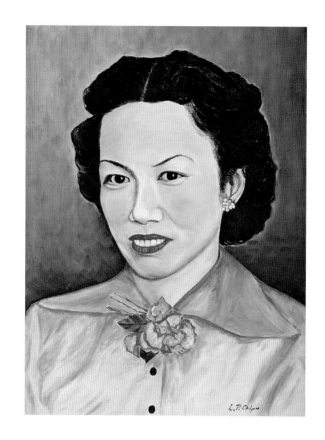

LAWRENCE CHINN

Portrait, ca. 1950s

Oil on canvas

Collection of Frances Chinn

Photo by Paul Macapia

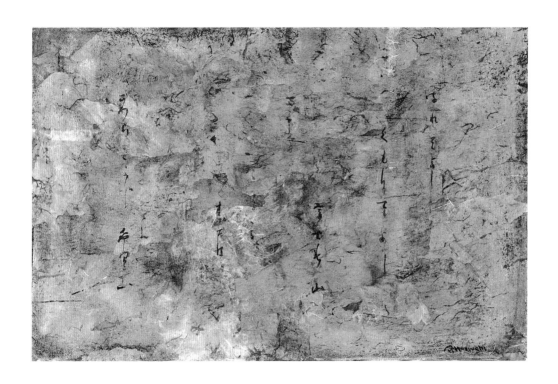

PAUL HORIUCHI

Writing From the Past, ca. 1950s

Mixed media

Collection of Debra and Peter Rettman

Photo by Paul Macapia

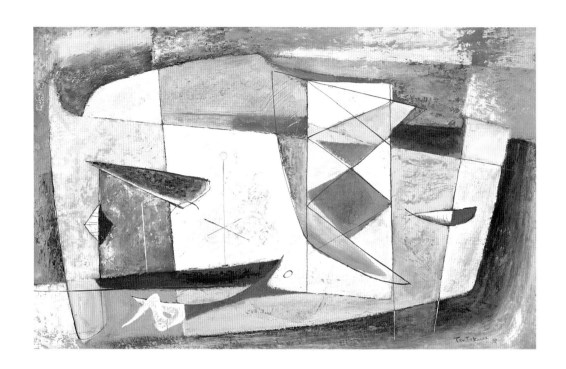

GEORGE TSUTAKAWA

Rescue # 1, 1958

Oil on canvas

Collection of the Artist

Photo by Paul Macapia

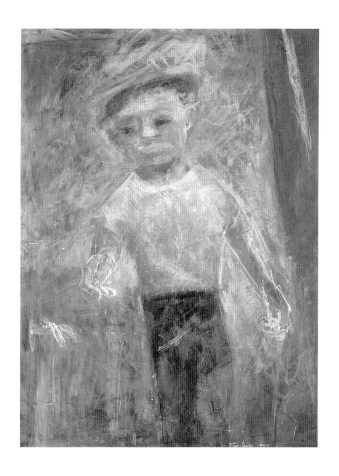

JOHN MATSUDAIRA

———

Tombo Tsuri, 1953

Oil on canvas

Collection of the Artist

Photo by Paul Macapia

VAL LAIGO

Dilemma of the Atom, 1953

Oil on canvas

Collection of Astreberta Laigo

Photo by Paul Macapia

FRANK MATSURA

———

Colville Woman, ca. 1910
B & W photograph
(Original negative is in the Collection
of the Okanogan Historical Society)

FRANK KUNISHIGE

———

Dancer, ca. 1927
B & W photograph
Collection of Special Collections Division,
University of Washington Libraries

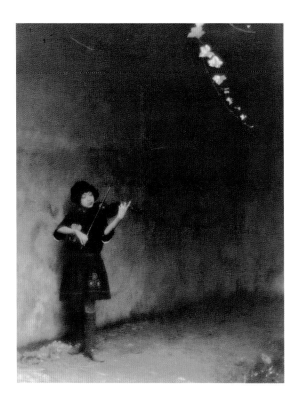

KYO KOIKE

———

Girl with Violin, ca. 1920s
B & W photograph
Special Collections Division,
University of Washington Libraries

HENRY TAKAYOSHI

———

Railroad Yard, ca. 1950s
B & W photograph
Collection of Mieko Hada

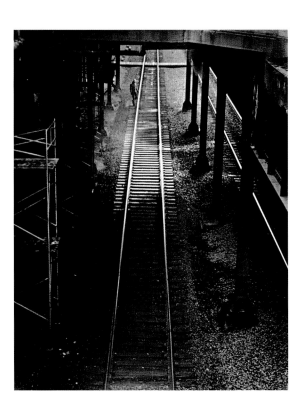

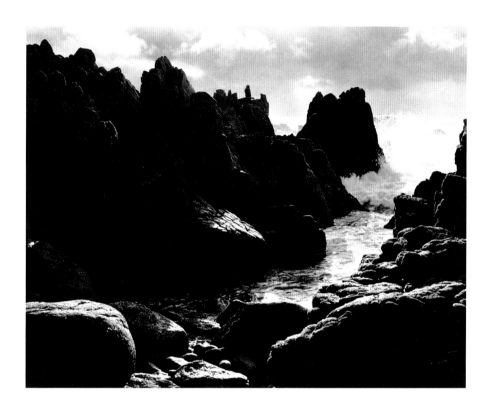

JOHSEL NAMKUNG

———

California Coast, ca. 1950s

B & W photograph

Collection of the Artist

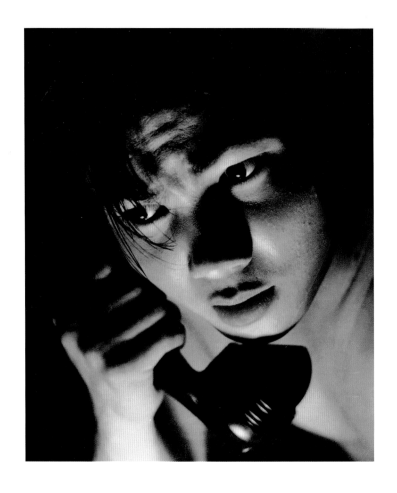

CHAO-CHEN YANG

Apprehension, 1951

Color photograph

Collection of Jean Yang

Interweaving Light with Shadow:

Early Asian American Photographers

in the Pacific Northwest

Interweaving Light with Shadow:
Early Asian American Photographers in the Pacific Northwest

BY KAZUKO NAKANE

SURROUNDED BY THE LUSH GREENERY of mountains and forests, the city of Seattle was founded in 1851. Yet true development came after the fire of 1889, when the city rebuilt itself, and the Alaska-Yukon-Pacific Exposition in 1909 which brought a considerable cultural stimulus to the area. The city's population jumped from 44,748 in 1890 to 311,583 in 1910.

As Seattle underwent this major transformation, Asahel Curtis, brother of Edward Curtis, documented through photography the re-shaping of the landscape that made urbanization possible. During this time, the Japanese immigrant population jumped from 125 in 1890 to 6,127 in 1910. Meanwhile, the Chinese, who had been driven out of Seattle in 1886 during the height of the anti-Chinese movement, remained small in number: 359 in 1890, 924 in 1910.

This history of Asian American photography began with the formation of the Japanese American communities at the turn of the century. In Seattle, Aiko Photo Studio opened in 1909 and the Toyo Photo Studio opened in 1917. The Jackson Photo Studio, Ochi Studio and Takano Studio all opened in 1921, closed during World War II, and then continued business well after the return of the Japanese to Seattle. In fact, the Seattle City Directory listed about twenty-five Japanese American photo studios from 1901 to 1942. The studio portraits of Takano Studio's Henry Miyake provide a record of the Japanese American community before the War, but most of their studio photos disappeared without a trace. In Spokane and Yakima in Eastern Washington, there also were communities of Japanese immigrants. There were informal

camera clubs organized there as early as 1906 (Roe 1983:22).

Among these early photographers, Frank Sakae Matsura (1874-1913) who took 2,500 photos (mostly dry glass plates) was exceptional. *Frank Matsura: Frontier Photographer* by JoAnn Roe (1981 and 1983) unfolds the mystery of this unique individual. Leaving Japan in 1901, Matsura came to the remote area of Okanogan in Eastern Washington in 1903. He did not have a noticeable foreign accent because he had learned English at a mission school in Tokyo which his uncle managed. He was baptized by the principal of the school, and he probably was introduced to the camera by the same person (1983:21). In Okanogan, he got a job at the Elliott Hotel where he practiced photo processing in the washroom. In 1907, he finally opened his own photo studio.

FRANK MATSURA

Through his photography he recorded the disappearing history of the frontier in Okanogan County. His intelligence, humor, and compassion allowed Matsura to capture his subjects with deep understanding. His photos not only depicted public and social events but also opened a door to every aspect of community life: from railroad crew members crowding themselves around box cars on rails pulled by horses to young women taking a relaxing swim in the river. There is an amusing description of a woman: "Minnie McDonald was known to like fine horses. She wound up in jail for horse theft" (1981:32).

While photographers were recording the world around them, Pictorialism was the dominant international photographic movement from around the 1890s to World War I. It began with the sincere desire to bring photography into the

arena of fine art. At the same time, the Arts and Crafts movement peaked in the United States, fostering the creation of new societies, guilds and classes. This movement focused on social consciousness in art and the making of art. It also applied the principles of fine art to architecture, crafts and graphic art, including photography. One of the most popular textbooks on the Arts and Crafts movement, *Composition* by Arthur Wesley Dow, was published first in 1899 and reprinted several times. Dow was profoundly moved by the printmaker Hokusai and his embrace of Japonism spread across the nation.

On the East Coast, in order to establish photography as an art form, Alfred Stieglitz organized "Photo-Secession" in New York in 1902. On the other side of the country, Imogen Cunningham, a member of the Seattle Fine Arts Society, began her photographic career around 1910. While studying in Europe, she saw an International Photographic Exposition and met Stieglitz on her way back to Seattle. The title of one of her photos, *The Wood Beyond the World* (1912), is taken from the publication by William Morris who left a lasting influence on the Arts and Crafts movement which began in England.

Cunningham left for California in 1917, the same year two Japanese men arrived in Seattle. Frank Asakichi Kunishige (1878-1960) landed in San Francisco in 1896 and graduated from Effingham College of Photography in Illinois about 1911. Coming to Seattle after that, he worked in the darkroom of McBride Studio until World War II. Dr. Kyo Koike (1878-1947) left Shimane Prefecture and arrived directly in Seattle. As a physician with public speaking skills, he was well respected by his fellow Japanese. Training himself to write in English by translating volumes of Japanese literature, he further cultivated interests in writing haiku, stamp collecting and mountain climbing. He became friends with Glenn Hughes, a pivotal figure

in the development of drama in Seattle, through his translation of Japanese plays. But for Dr. Koike, photography was his most serious interest.

In the 1920s, cultural activities in Seattle most often took place through societies and clubs. The Seattle Fine Arts Society was formalized in 1908 and hosted many exhibits. The painter Fokko Tadama from Holland and Japanese artist Yasushi Tanaka from Saitama Prefecture, Japan (who left Seattle for Paris in 1920) both had private art schools, and nurtured many local artists. Mark Tobey's work at the Cornish School and Ambrose Patterson's influence at the University of Washington brought fresh ideas to the local art scene.

KYO KOIKE

In 1920, the first photographic competition took place at Frederick & Nelson department store. Wayne Albee, noted Pictorial photographer, praised the photos of Soichi Sunami (1885?-1971) in the local magazine *Town Crier* (December 17, 1921). Sunami later moved to New York to become a staff photographer at the Museum of Modern Art for three decades. Koike, Kunishige and about twenty other Japanese photographers formed the Seattle Camera Club in October, 1924. Dr. Koike became the leader and editor of their bilingual monthly magazine *Notan*, published from 1925 to 1929. The Club invited local and visiting artists, including Mark Tobey, to speak at monthly meetings.

Though Kunishige's work began with fabricated images of allegorical pursuits from the earlier tradition of Artistic Photography, he was known for female nudes. The depiction of an idealized unclothed female body in the late nineteenth century tradition was enormously popular in the United States and France, and American artists sought to emulate qualities within that tradition. One of Kunishige's noted photos, *Spring Pasture,* is evocative of the bucolic Barbizon School of painting.

FRANK KUNISHIGE

What distinguished him from others was his exceptional technical ability to capture a mood of delicacy using subtle gradations of tonality. To maximize this effect, Kunishige experimented with the already popular Japanese rice paper and created his own, Textura Tissue.

When Kunishige had a solo exhibit of seventy of his works at the Commerce Club in Chinatown in 1924, he had already achieved maturity as a photographer. He was aware of new movements among artistic photographers. As early as 1904, the art critic Sadakichi Hartman who had written over 500 articles to advocate Pictorial photography, wrote *A Plea for Straight Photography* in *American Amateur Photographer* (March issue): "Photography must be absolutely independent and rely on its own strength in order to acquire that high position." Later works by Kunishige shed the symbolic world, instead incorporating the picturesque scenery of a more common reality while still maintaining a European aesthetic.

The Pictorialism movement was diverse, and as Hartman wrote in *Camera Notes* (October 1898), "In higher stages photography can reflect all the subtleties on a man's mind." Koike's images in his photos also were the reflection of his inner thoughts. He was not simply capturing the typical scenery of Northwest landscape. His own sense and belief in Japanese aesthetics also had been provoked by Dow's *Composition*.

The principles of composition are underlined in the work of Koike. His most successful works look spontaneous and feature a simplicity and harmony of composition. Koike said, "When I am inspired by something, I try to catch the first momental impression . . . my first impression won't betray me." (*The Ground Glass,* October 1925). He enjoyed walking leisurely to search out shots of mountains and a sky filled with clouds. Similar to Asian brush painting, which expresses personal moods through the use of landscape, Koike's compositions reflect a poetic lyricism. He said,

"Say less, and feel more" (*Camera Crafts,* March 1925).

At its peak in 1925, one quarter of the Seattle Camera Club's members were Japanese. Its members, including the noted Ella McBride, received numerous international prizes. Fred Ogasawara, who held an honorable membership in the Oregon Camera Club from 1924 to 1930, sought the profound in beauty. Y. Morinaga, who worked at Virna Haffner's Photo Studio in Tacoma and did most of the printing for Koike, produced photos that went beyond a preconceived pictorial frame, capturing an instant of everyday life in an urban landscape. Hideo Onishi went through laborious efforts to produce an image, sometimes overlapping several negatives. Hiromu Kira moved on to Los Angeles and interpreted newly evolved West Coast photography with his images.

The Seattle Camera Club folded in 1929 due to the Depression and new directions in the world of photography. From the late 1920s, Seattle artists began to look outward; they were swept up by Futurist and Cubist art in Europe, painters of the Ash Can School in New York and the influence of ethnic arts of the world, particularly from Asia. Koike was aware of a new photographic movement represented by the works of Edward Weston. West Coast photographers began to seek the beauty in common things and used straight photography to capture the quintessence of objects.

Koike and other members of the Seattle Camera Club continued to seek serenity in their art during the era of the 1930s, when other American artists were caught up in the mood of heightened social consciousness. When World War II broke out, Japanese Americans had their cameras and radios confiscated and were sent to camps under suspicion as enemy aliens.

Chao-Chen Yang (1910-1969) came to Seattle in 1939 af-

ter serving as a Deputy Consul for the Chinese Consulate in Chicago. Having already received a bachelor's degree in art in Shanghai, he registered for an evening photography class at Chicago Art Institute. Though he did not know anything about the camera at first, his photo *Three Men* was chosen as one of the best photos while he was still a student at the Institute. The photo is strikingly direct and modern, capturing the energy of city life in Chicago while he continued to serve as a Chinese Deputy Consul. In Seattle he began taking images of nature. His photos were accepted at the salons of Pictorial photography in the area almost annually from 1941 to 1955.

Que Chin (1922-1974) was also a Pictorial photographer. He came from Kwangtung Province in 1927. He began his photography after being bedridden for years due to a bone infection. After a partnership with Yang in 1941, he opened the Que Chin Studio of Photography in 1945. He was a portrait specialist known for his skillful retouching and ability to capture mood through the use of Rembrandt-like lighting. One of the photos he took outside of his business is *Midnight Conversation,* a composed picture. The light brings forth an intimacy between two men on different planes silenced by the hovering tree in the darkness. The theme was loved by many other photographers.

While amateur photographers explored gradations between black and white, professional photographers made great advancements in color photography particularly in the film industry and the world of advertising. Chao-Chen Yang's preoccupation with the camera overlapped with film, and in 1946 he studied at RKO Studio in Hollywood in order to learn motion picture and color photography. The following year he opened the Northwest Institute of Photography where Yuen Lui (1910-1974), Yung Chin (1916-) and Elmer Ogawa (1905-1970) became students. Lui es-

CHAO-CHEN YANG

HENRY TAKAYOSHI

tablished his own photo portraiture businesses in town. Chin worked in darkrooms for The Boeing Co. and Ogawa became the first Japanese American newspaper photographer in Seattle, documenting much of the community's daily life. Yang opened Yang Color Lab in 1951 and was sought after for his expertise in color photography. He was known for his skill in Dye-Transfer, and he specialized in commercial photos of food in which the product was depicted as deliciously appealing. In 1955, he made a trip to Europe to pursue his artistic photography.

The legacy of Pictorial photography later was picked up by a new generation of Japanese Americans. Yoshio Noma was inspired by Koike, and organized an amateur photographers' group in 1941. He again organized other groups after the war. Some members through the years included George Uchida, Clarence Arai and Henry Takayoshi. Uchida (1924-) went on to take photos of Mark Tobey for that artist's New York exhibition catalog. Arai (1901-1963) became a prominent attorney. Takayoshi (1899-1993) took pictures on his own for over 70 years.

In the 1950s, Northwest artists began to garner national attention. But the artistic circle was still small enough to allow the artists, a diverse group, to establish close rapport. Johsel Namkung (1919-), was born in Korea and came to Seattle from Shanghai in 1947. He became friends with George Tsutakawa and Paul Horiuchi, both of whom later became prominent artists in the Northwest. Giving up a career of singing German lieder which he had studied since his youth, he decided to learn the process of color photography with Yang in 1957. He fell in love with the camera and became primarily a color nature photographer, noted for his superb technique. In a Namkumg photo, the focus on a small section of nature will force every

"The legacy of pictorial photography later was picked up by a new generation of Japanese Americans"

detail of the natural formation to the surface, creating an abstract painting from an enlarged image. The result is the sheer beauty of combining color harmony and rhythmic movement. Namkung says, "I feel the emotion from the subjects. It is not my emotion. They emanate emotion so I can photograph them" (*The Seattle Sun*, April 12, 1978).

All the photographers represented here are Asian Americans whose artistic development was interwoven with American art history. Their importance lay here in the Northwest where the influence of Asia has long been recognized. The Pacific Northwest featured not only a geographic closeness to countries of Asia, but also many Asian American artists whose works, as well as their personal associations, provided an essential character to the art of the Pacific Northwest.

Copyright © 1994 by Kazuko Nakane. Portions of this essay were excerpted from *Shade and Shadows: An Asian American Vision Behind Northwest Lenses* (with Alan Chong Lau) which originally appeared in *The International Examiner* (1991) and from "Eyes Behind the Camera: Early Japanese American Visions," a talk given at the annual conference of College Art Association, New York, 1994.

Bibliography
Artists Scrapbooks, Seattle Downtown Public Library
Johsel Namkung: An Artist's View of Nature, Seattle Art Museum, 1978
Manuscripts and Special Collections, Allen Library, University of Washington
Monroe, Robert, "Light and Shade: Pictorial Photography in Seattle, 1920-1940,

JOHSEL NAMKUNG
PHOTO BY KEN LEVINE

and the Seattle Camera Club," in *Turning Shadows Into Light*, Mayumi Tsutakawa and Alan C. Lau, eds., Seattle: Young Pine Press, 1982, pp. 8-32

Reed, Dennis, ed. *Japanese Photography in America 1920 - 1940*, Los Angeles: Japanese American Cultural and Community Center, 1981.

Roe, JoAnn, *Frank Matsura: Frontier Photographer*, Seattle: Madrona Publishers, 1981, trans. in Japanese with an additional introduction by Ko Ishikawa, Tokyo: Heibonsha, 1983

Town Crier, 1917-1929

Zabilski, Carol, "Dr. Kyo Koike, 1878-1947," in *Pacific Northwest Quarterly*, April 1977, pp 72-79

Kazuko Nakane is an independent arts writer and historian. She is the author of *Nothing Left in My Hands* (Young Pine Press, 1985). Her writing has appeared in *Reflex, Visions* and *The International Examiner.*

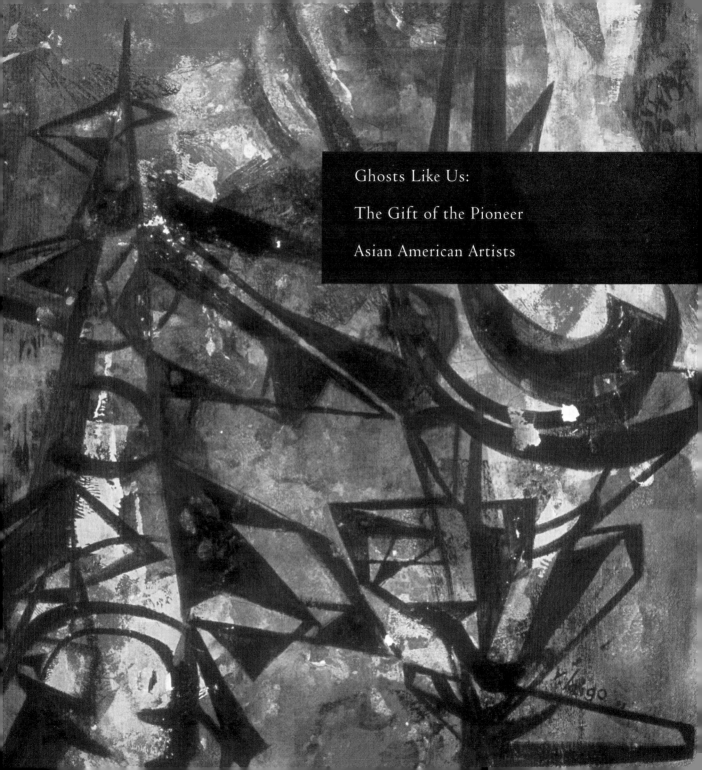

Ghosts Like Us:

The Gift of the Pioneer

Asian American Artists

Ghosts Like Us: The Gift of the Pioneer Asian American Artists

BY LUCIA ENRIQUEZ

Every culture reaches within itself for a language with which to define and express its life. This language, embodied in works of art, draws from the experiences and anticipations of individual members of a community in order to more deeply represent the broader culture. A kind of economy governs this process, with artists creating work for their culture in order to realize themselves, and in doing so, allowing the community to maintain its coherence and viability.

Asian American art has had a relatively short history, only recently coming into its own as a recognized art movement. What started out as the isolated artistic efforts of a number of individuals of Asian ancestry in the early part of this century is becoming, toward its end, an institutionalized art genre. At this point in its evolution, what represents the movement is not any particular artistic style but rather conditions and messages describing the social and political reality of Asian America. Although many Asian American artists derive influences from variously linked Asian and American traditions, a sense of diversity, independence and resiliency rather than the propagation of tradition propels the movement.

The Asian American community in Washington state in the 1990s includes newly arrived immigrants as well as those who have settled here for generations. Within this dense mix resides an even more complex blend of lives and histories. What is Asian American, however, lies between the fragments of the diverse nationalities and generations of this population. It comprises what these people were not before, what they become when extended into a larger community that accommodates the part of them that is foreign but is itself indigenous to the United States. Reminders of the Asian American community's past are

accumulated on the facades of the streets of Seattle. From the hallways of the Bush Hotel to the benches at Hing Hay to the Val Laigo mural at Rizal Park, they stand in quiet commemoration of individuals as preoccupied with building their lives as any generation, and as involved in creating a sense of identity as any culture, but who bore the additional burden of being discriminated against and alienated in American society because they were Asian American. Nevertheless, they left a cultural and historical legacy that continues to nurture Asian American artists today.

My own tie into this community comes from being a first generation immigrant. My family came over to the United States from the Philippines in 1981, choosing Seattle as our destination in part to avoid Los Angeles, a city which on first impression looked nothing more than a glossier version of Manila. We came on the crest of the fourth wave of Philippine migration to the United States in this century, a generation taking advantage of increased immigration quotas and the opportunity to flee the Philippines under the late President Ferdinand Marcos. So many of our friends and relatives had already ventured thus. In terms of numbers, we embarked unremarkably, just another Filipino family filling out the already burgeoning mass of transplants to the North American continent.

After fourteen years, we have come to call the United States, or Seattle to be more specific, home in some permanent sense despite the layered comments dropped at any one of the multi-generational, four-hour weekend lunches at my parent's house. At these times, the loose mix of Tagalog and English that is spoken forces the conversation into a kind of murkiness, with Manila and memory lurking in

the depths of the words. Their vagueness functions no more and no less than a kind of negative possibility for the hope of bringing past and present together. Still the conversations establish a sense of place even if only to accommodate a sublimated, though persistent, feeling of displacement.

Through sheer will, determination, and immigrant tolerance for the unexpected, we made our lives with whatever came our way. I now watch North American-born nieces and nephews growing up with just vague awareness of their cousins in the Philippines and more recently, in Europe. Even more remote to their knowledge is the landscape, the language, and the myths that my siblings and I lived. Quite beside ourselves we feel compelled to adapt, to formulate a different notion of home to accommodate the new myths, the next generation, the new stories of our family taking root.

With this background I join in the community of Asian American artists, individuals similarly seeking means to express the complex, often disrupted geographies of their cultural experience. This experience comprises any combination of salvaging the memory of a distant homeland, struggling with alienation in the United States, or cautiously negotiating the process of assimilation, among others. Like them I weave my way through the tortuous hallways of multiculturalism and identity politics. In this community my alienation feels companionship.

Fundamental to this effort is the creation of a different sense of heritage, one that at first seems to go opposite the grain of the immigrant who sees the new land fresh but forbidding; who, feeling the loss of a life's strain of culture and history, feels much compunction in connecting deeply with their newly encountered

environment; who arrives with a one way ticket and single-minded prospect of future accomplishment. Heritage in this case means gathering the accumulated strands of stories about Asian artists in America and making them available for interpretation by a more diverse and connected Asian American community. This heritage consists of the lives of older generations of Asian American artists, individuals such as Val Laigo, George Tsutakawa, Carlos Bulosan, and scores of others who lived in an America less hospitable to aliens, who were pioneers in recasting the shards of dichotomized Asian American culture.

True works of art are gifts, wrote the poet Lewis Hyde. And every gift, according to the anthropologist Marcel Mauss, "strives to bring to its original clan and homeland some equivalent to take its place." What does it mean for Asian American artists to give homage, to give something back from whence they came; what does it mean for Asian American works of art to be gifts when the defining quality of a work of art is its loss of self consciousness or alienation, its feeling of having arrived home?

Certainly there has been no shortage of Asian American art produced in recent decades despite disruption and alienation. In fact the Asian American art movement shows no signs of slowing down, taking advantage of increased acceptance and strength in numbers. But along with this increased strength is a rise in the awareness of the movement's roots and the creation of a community of their own kind. Being connected to this history gives contemporary Asian American artists a different foundation with which to make their art and their culture; it provides Asian American artists who are active at this time something that the pioneers never had: a sense of themselves and their work in connection and in identification with a larger community.

"Heritage in this case means gathering the accumulated strands of stories about Asian artists in America"

It brings about a place for us to call home. It gives us history, the sense of something old — local, tangible ghosts and spirits with whom to identify.

The legacy of the pioneers gives current Asian American artists a space within the stream of American art history from which to expand the bounds of American culture. This current community includes artists such as Manuel Ocampo, Patti Warashina, and Yong Soon Min, individuals changing the face of American culture and, in fact, representing the avant garde. If the legacy left to us by the pioneer Asian American artists is the possibility of asserting an alien cultural aesthetic in the midst of American art, the responsibility of current Asian American artists to the future is a dynamic and diverse American culture borne both out of indigenous and alien restlessness and spunk.

Lucia Enriquez is a Filipina American artist and writer. She has lived in this country for fourteen years and has written extensively on cross-cultural issues. She comes from a family of twelve children who currently reside in four different countries on three continents.

Asian American Artists Directory

Foreword

The Archives of American Art, founded in 1954, has assembled the world's largest collection of record documenting the history of the visual arts in the United States. More than twelve million items o original source material are available for study to scholars, students, writers and other researcher A bureau of the Smithsonian Institution since 1970, the Archives preserves its original documents i Washington, D.C. The most actively used collections are microfilmed, and microfilm copies are depos ited in the Archives centers in Washington, New York, Detroit and San Marino, California. The micro film is also available at research centers in Boston (Fine Arts Department, Boston Public Library) and i San Francisco (M.H. de Young Memorial Museum). The original material is thus protected from los or destruction while copies are readily accessible to scholars in the centers or through inter-library loar The Archives has not only the records of American painters, sculptors, craftsmen, collectors and dealer but also those of critics, historians, curators, musicians, societies and other institutions.

Affiliation with the Smithsonian Institution makes the Archives of American Art part of on of the world's greatest research centers in the arts and sciences. However, the Institution's support doe not cover all of the Archives' operating costs. The Archives Trustees raise a substantial portion of th annual budget through private gifts. Such funding underwrites approximately half of the staff, support national collecting, and enables the Archives to publish its quarterly Journal.

Reclaiming the Past:
Northwest Asian American Artist Project

The Northwest Asian American Artist Project was initiated in 1989 by the Smithsonian Institution's Archives of American Art as a carefully focused effort to begin documenting artistic activity within a specific community. In a broader sense, the goal was to expand our understanding of the American cultural experience by proposing a more inclusive art history, one that would incorporate heretofore overlooked individuals and groups. Since locating and preserving documentary evidence of the story of art in America in as comprehensive manner as possible is the primary function of the Archives, this three-year project seemed especially worthy and timely.

The Project was inspired by a video interview conducted in 1987 with Seattle sculptor George Tsutakawa as part of the Archives oral history program. Funded with a grant from Warner Communications, the video was originally limited to several days of shooting with Tsutakawa in his studio and at several fountain sculpture sites in the Puget Sound area. However, the opportunity one year later to follow Tsutakawa to Japan to record the installation of a piece commissioned by his ancestral city, Fukuyama, broadened the scope of the project to address the issue of artistic expression based in two cultures. A major theme that emerged from the first interview was the question of creative identity among artists such as Tsutakawa and most other Asian Americans of his generation, who struggled to reconcile the influence of a strong "spiritual homeland" tradition with the energy and democratic individualism of America. It became evident that our understanding of American art would remain incomplete without taking this phenomenon into account. Due to the relatively strong Asian presence in the region, the Pacific Northwest seemed to provide an ideal case study. So, with support from the Henry Luce Foundation, the Archives created a project to begin assembling the essential documentation.

The Northwest Asian American Artist Project was conceived and administered by the Archives West Coast Regional Center, at the time located in San Francisco. The first phase involved a survey conducted by Alan Lau and Kazuko Nakane, the purpose of which was to identify, for archival collecting, artists (broadly defined) of Asian American descent active in Washington and Oregon from 1900 to about 1975. In this process, coordinators Lau and Nakane conducted extensive research and personally interviewed numerous artists, their families and heirs. Their efforts produced the most complete listing to date of Asian American artists in the Pacific Northwest region. It is this listing that began to assume the form of an artist directory, in effect a marvelous byproduct of the Project. The present exhibition and catalogue provide the happy occasion for publication of this information.

The second, collecting phase of the Project was coordinated by Barbara Johns, now curator c exhibitions at the Tacoma Art Museum. Johns, who also completed another major Archives endeavor, th Northwest Oral History Project which produced over 27 taped interviews (the transcripts of whic were also deposited at the University of Washington and Oregon Historical Society where they may b consulted), based her work on the findings of the preliminary survey. As a result of her efforts and c subsequent regional collecting activity, papers and/or interviews of twelve individuals are now preserve at the Archives. Among the artists now or about to be represented are: Andrew Chinn, Val Laigo, Joshe Namkung, Frank Okada, Norie Sato, Roger Shimomura, Yasushi Tanaka, Kamekichi Tokita, Georg Tsutakawa, Patti Warashina, and Chao-Chen Yang.

As has been indicated, the Directory was compiled by Lau and Nakane, and the information in th individual entries reflects, in edited form, what they were able to uncover in the sources available t them. For many artists, biographical and bibliographical data was scarce; in the cases of better know figures there was a plethora. The Directory as it appears here has been edited to provide uniformit between entries, the idea being to introduce the artists themselves with enough basic information to giv some idea about their lives and careers. Further data, for instance extended chronologies or exhibitio histories for Shimomura or Warashina, may be found in the original artist listing available from th Archives. In some cases full bibliographical and exhibition listings appear in retrospective catalogue (e.g. Martha Kingsbury on Tsutakawa, 1990) and other books, many of which appear in the Director as references. Of course, the primary research sources are the papers and interviews themselves, whic serious students will need to consult.

In connection with the Project and the Directory, the Archives would like to thank the following Alan Lau and Kazuko Nakane, Barbara Johns, Lawrence Fong, Gerald Bolas, Patterson Sims, Mayun Tsutakawa, David Ishii, Helen Abbott, Laela Weisbaum, Marshall and Helen Hatch, and the Henry Luc Foundation. We are grateful to Ron Chew and the Wing Luke Asian Museum for providing this oppor tunity to share some of the results of our work in this important field.

Paul J. Karlstrom
West Coast Regional Director
Archives of American Art/Smithsonian Institution

A Directory of Asian American Artists in Washington and Oregon (1900-1975)

The Northwest Asian American Art Project

Archives of American Art

Smithsonian Institution

COMPILED BY ALAN LAU AND KAZUKO NAKANE, 1990

KEY TO ABBREVIATIONS

ASDSPL: Artists Scrapbooks, Seattle Downtown Public Library
AUOL: Archives, University of Oregon Library, Eugene
HAG,UW: Henry Art Gallery, University of Washington
MALUW: Manuscripts, Allen Library, University of Washington
M&SCALUW: Manuscripts and Special Collections, Allen Library, University of Washington
PAM: Portland Art Museum
SAM: Seattle Art Museum
SAML: Seattle Art Museum Library

FULL CITATIONS OF AUTHOR/DATE REFERENCES

Appleton, Marion, B., ed., *Who's Who in Northwest Art* (Seattle: Frank McCaffrey, 1941)
Guenther, Bruce, *50 Northwest Artists* (San Francisco: Chronicle Books, 1983)
Johns, Barbara, *Modern Art from the Pacific Northwest* (Seattle: Seattle Art Museum, 1990)
Kingsbury, Martha, *Art of the Thirties: The Pacific Northwest* (Seattle and London: University of Washington Press, 1974)
"Seattle and Puget Sound," Martha Kingsbury, *Art of the Pacific Northwest* (Washington, D.C.: Smithsonian Institution, 1974)
Kingsbury, Martha, *Northwest Traditions* (Seattle: Seattle Art Museum, 1978)
Pierce, Mrs. Harry Paul, *Roll of Artists* (Washington State Federation Women's Clubs, 1924-26)

Reed, Dennis, in *Japanese Photography in America 1920-1940* (Los Angeles: George J. Doizaki Gallery, 1986)
Some Work of the Group of Twelve (Seattle: Frank McCaffrey, Dogwood Press, 1937)
Tsutakawa, Mayumi, and Alan Lau, eds., *Turning Shadows into Light* (Seattle: Young Pine Press, 1982), including Robert D. Monroe, "Light and Shade: Pictorial Photography in Seattle, 1920-1940, and the Seattle Camera Club

PLACE NAMES

Bellevue, Seattle, Spokane, and Tacoma are in Washington State. Portland is Portland, Oregon, unless otherwise noted. University of Washington refers to the main campus in Seattle.

Please note that newspaper and periodical references appear here only when they are the sole sources. Listings for exhibition and solo shows are selected.

Directory information is based on Lau's and Nakane's compilation in 1990. Deaths since 1990 are noted, but no other updates or additions have been made to the text. Sources are limited to those used by Lau and Nakane.

The designation of painting media in identifying an artist's work is used in the directory to distinguish Asian-influenced (watercolor and sumi) and Western (oil) artistic practices.

Artists included, State of Washington

ARAI, Clarence Takeya
BERKENKOTTER, Frank
CASTILLANO, Bibiana
CHIN, Que
CHINN, Andrew
CHINN, Lawrence
CHONG, Fay
ENG, Howard Sheng
FUJII, Frank
FUJII, Takuichi
FUKU, Mitsutaro
FUKUMA, Marion
HATTORI, Scott
HO, Francis
HO, Raymond Tau On
HO, Ron
HORIUCHI, Paul
HOSODA, Kuraju
ISHII, Kowhoo
JUE, Priscilla, Chong
KATAYAMA, Mitsuru F.
KIMURA, Fumiko
KIRA, Hiromu
KISHIDA, Carl M.
KOIKE, Kyo, Dr.
KOREKIYO, Tsuyoshi and Misao
KUBOTA, Fujitaro
KUNISHIGE, Frank A.
KWEI, Dun
KWEI, Teng
LAIGO, Val
LEE, Dr. and Mrs. Su Jan
LEO-GWIN, Cheryll
LIN, Henry H.
LIU, Lucy
LOUIE, Art
LUI, Yuen
LUI, Wah
LUKE, Keye
MACAPIA, Paul
MATSUDAIRA, John
MATSUSHITA, Iwao
MATSURA, Frank
MIYAZAKI, Shiro
MONIZ, Haruko
MORINAGA, Yukio
NAKASHIMA, George
NAMKUNG, Johsel
NAMKUNG, Mineko
NISHII, K.
NOMA, Yoshio
NOMURA, George

NOMURA, Kenjiro
OGAWA, Elmer
OHNISHI, Hideo
OKA, Keith S.
OKADA, Frank
OKAMURA, Nori
OKAZAKI, Authur
OSAKA, Michi
PASCUAL, Nemesio A.
SATO, Norie
SAWADA, Ikune
SHIMIZU, Toshi
SHIMOMURA, Roger
SUNAMI, Soichi
TAKASUMI, Fred
TAKAYOSHI, Henry
TAKIZAKI, James
TANAKA, Yasushi
THIEL, Midori
TOKITA, Kamekichi
TOMITA, Genzo
TSE, Yuen K.
TSE, Stephen
TSUTAKAWA, Edward M.
TSUTAKAWA, George
UCHIDA, George
WARASHINA, Patricia
WONGSANGUAN, Burin
YAMAGISHI, Teizo
YAMAZAKI, Minoru
YANG, Chao-Chen

Artists included, State of Oregon

CHEN, B. Wai
DOZONO, Robert R.
FONG, Wylog
FURUYA, Kyuzo
GONG, Fred
HOY, Kathy
HOY, Harold
KEE, Bue
KOSUGE, Michihiro
LAU, Fook Tai
LEONG, Wing
MIZUNO, Sadao
MORIYASU, Kenyu
MURASE, Robert
NIGUMA, Rose
OGASAWARA, Fred
OKADA, FRANK
PICKETT, Setsuko B.
TOMINAGA, Jo
TSUNEMITSU, Joe
WONG, Allen Q.

ARAI, Clarence Takeya
(1901-63)
Japanese American
Photographer
Biography: Born in Seattle;
1924 J.D. in Law, University
of Washington; 1930s
married Yone Utsunomiya
Sources:
MALUW

BERKENKOTTER, Frank
German-Filipino American
Printmaker, active 1930s
Sources:
The Journal of Ethnic Studies,
vol. 4, no. 1, 1976, p. 13

CASTILLANO, Bibiana
(b. 1904)
Filipino American
Painter
Biography: Born in Naguilian,
La Union, Philippines; until
1928 taught music and art in
Naguilian; 1928 moved to
the United States
Exhibited: Foster/White
Gallery, Seattle, mid-1970s
Sources:
MALUW

CHIN, Que, or Jue Gong
Chin (1911-1974)
Chinese American
Portrait photographer, spe-
cializing in photo finishing
Biography: Born in
Kwangtung, China; 1927
moved to the United States;
well read in European,
American, and Chinese litera-
ture; 1941-45 business part-
ner with Chao-Chen Yang
and managed Cathay Studio;
1943-50 submitted and
accepted at 91 photographic
salons; 1945-74
owner-director of Que Chin
School of Photography
Exhibited: Massachusetts
Institute of Technology
Gallery, Cambridge, late
1940s; Seattle Public

Library, date unknown
Sources:
International Examiner,
Jan. 23, 1991

CHINN, Andrew (b. 1915)
Chinese American
Watercolor painter
Biography: Born in Seattle;
1917-26 and 1929-33 lived
in China; Sept. 1933
returned to Seattle; 1939
studied English at the
Y.M.C.A. and art at Broadway
High School with Miss Piper
and attended Franklin High
School; 1939-41 studied art
with Ray Hill, Ruth
Penington, Hans Lee, at the
University of Washington;
often sketched with Fay
Chong, Morris Graves, and
Guy Anderson; 1945 began
teaching watercolor painting
Exhibited: The Northwest
Annual, SAM, 1940-42,
1946-47, 1949, 1951, 1953,
1956, 1958-60
Solo shows: SAM, 1942; Frye
Art Museum, Seattle, 1953,
1987
Sources:
Appleton, 1941
Puget Sound Group of
Northwest Painters, *First Fifty
Years* (Seattle: The Group,
1979)
Tsutakawa & Lau, 1982
ASDSPL
MALUW
SAML

CHINN, Lawrence, or
Lawrence Yuen (1914-1994)
Chinese American
Painter and kite maker
Biography: Born in the same
village in Kwangtung, China,
in which Andrew Chinn was
educated; studied still life,
portraits, water color, char-
coal, and brush painting at
Chek Sheh Art Institute,
Canton City, China, while
a high school student;
attended Franklin High

School, Seattle; 1935
attended aviation school;
became an aircraft engine
mechanic
Sources:
Tsutakawa & Lau, 1982

CHONG, Fay (1912-1973)
Chinese American
Painter and printmaker
Biography: Born in
Kwangtung, China; 1920
came to Seattle; attended
Broadway High School,
where he met and worked
with Morris Graves and
George Tsutakawa; 1928-32
studied printmaking with
Hannah Jones; 1938-42
worked for WPA project; late
1930s took a class from
Mark Tobey; 1968 B.A. and
1971 M.A. in Art Education,
University of Washington,
Seattle
Exhibited: The Northwest
Annual, SAM, 1940-43,
1955-61, 1963, 1967
Solo shows: SAM, 1942, 1957;
Frye Art Museum, Seattle,
1953; Zoe Dusanne Gallery,
Seattle, 1954; Reed College,
Portland, 1954; Santa Bar-
bara Museum of Art, Califor-
nia, 1956; Riverside Gallery,
New York, 1956; Francine
Seders Gallery, Seattle,
1972; Bellevue Art Museum,
1976; Carolyn Staley Fine
Prints, Seattle, 1990
Sources:
Appleton, 1941
*Northwest Artists in Otto
Seligman Gallery*, 1962
*Puget Sound Group of Northwest
Painters*, 1979
Kingsbury, 1972
Tsutakawa & Lau, 1982
MALUW
SAML
ASDSPL

ENG, Howard Sheng
(1909-1949)
Chinese American
Oil painter
Biography: Born in Manila,
Philippines; 1924 moved to
the United States; 1927-28
began to paint; attended
Cornish School, Seattle
Exhibited: The Northwest
Annual, SAM, 1948;
Frederick & Nelson Gallery,
Seattle; HAG,UW
Sources:
The Seattle Times, April 25,
1948

FUJII, Frank (b. 1930)
Japanese American
Mixed-media designer and
painter
Biography: Born in Seattle;
1952 B.A. in Commercial
Art, University of Washing-
ton; 1956 B.A. and 1964
M.A. in Art Education and
Fine Art, University of
Washington; 1965-72 taught
at Franklin High School,
Seattle, and 1972-78 at
Seattle Central Community
College
Exhibited: Wing Luke Asian
Museum, Seattle, 1977, 1992
Sources:
Seattle Post-Intelligencer,
Feb. 21, 1959

FUJII, Takuichi (b. 1892)
Japanese American
Oil and watercolor painter
Biography: Born in Hiroshima
Prefecture, Japan; one of the
"Group of Twelve"; after
World War II moved to
Chicago
Exhibited: The Northwest
Annual, SAM, 1930-35,
1940-41
Sources:
*Some Works of the Group
of Twelve*, 1937
Appleton, 1941
SAML, Kamekichi Tokita's file
MALUW

FUKU, Mitsutaro
Japanese American
Photographer
Biography: Owned a Capitol
Hill grocery store, Seattle
Biography Japanese Chamber
of Commerce, Seattle
Sources:
The Seattle Times, Feb. 3, 193⁴
The Town Crier, Dec. 1935

FUKUMA, Marion
(b. 1931)
Japanese American
Printmaker
Biography: Born in Seattle;
1949-52 studied art at Uni-
versity of Washington; 1955
B.F.A. School of Art Institute
of Chicago
Exhibited: Panaca Gallery,
Bellevue, 1979-80; Wing
Luke Asian Museum,
1979-81, 1983-85
Sources:
The Seattle Times, June 24,
1979
International Examiner,
July 6, 1983; July 15, 1987

HATTORI, Scott
(1928-1960)
Japanese American
Oil and acrylic painter; set
and costume designer
Biography: Born in Seattle;
early 1950s proprietor of
Haru, a shop on E. Broad-
way, Seattle, specializing in
Japanese arts and crafts
Exhibited: The Northwest
Annual, SAM, 1959
Sources:
The Seattle Times, Jan. 10,
Jan. 25, 1960

HO, Francis T. (b. 1938)
Chinese American
Photographer
Biography: Born in Honolulu;
since 1967 has taught at
Washington State University,
Pullman
Sources:
Hose Valley (Holland: Rosbee
of Hoensbroek, 1976)

...IO, Raymond Tau On
(b. 1939)
...apanese American
...eramist and collage painter
...iography: Born in Honolulu;
...962 B.A. in Art Education,
...acific Lutheran University,
...acoma; 1970 M.F.A. in
...eramics, University of Puget
...ound, Tacoma; 1973-85
...aught at Lakes High School,
...acoma
...xhibited: State Capitol Mu-
...eum, Olympia, 1963; The
...lorthwest Annual, SAM,
...963-64, 1966-67;
...HAG,UW, 1969, 1971
...olo shows: Pacific Lutheran
...University, Tacoma, 1964,
...979; Bau-xi Gallery,
...ancouver, British Columbia,
...965, 1967, 1969, 1977;
...acoma Art Museum, 1965;
...oos Bay Art Museum,
...Dregon, 1975
...ources:
...Harrington, 1979
...MALUW
...AML

...IO, Ron (b. 1936)
...hinese American
...ewelry artist
...iography: Born in Honolulu;
...958 B.A. in Art Education,
...acific Lutheran University,
...acoma; 1968 M.A. in Art
...ducation (took jewelry
...esign classes from Ramona
...olberg), University of
...Vashington; since 1958 has
...aught art at elementary and
...igh schools; 1978-79 trav-
...ed in Europe, the Middle
...ast, and Asia
...xhibited: HAG,UW, 1971,
...973, 1975; American
...rafts Council Gallery,
...merican Craft Museum,
...ew York, 1973; Portland
...rt Museum, 1974; Tacoma
...rt Museum, 1978; Wing
...uke Asian Museum, Seattle,
...980; Renwick Gallery,
...mithsonian Institution,
...Vashington, D.C., 1981-83;

Kohler Arts Center,
Sheboygan, Wisconsin,
1984; Bellevue Art Museum,
1979, 1981, 1984, 1986-87,
1990
Solo shows: Northwest Craft
Center, Seattle, 1975;
HAG,UW Seattle, 1976;
Wing Luke Asian Museum,
Seattle, 1988
Sources:
MALUW
SAML

HORIUCHI, Paul, or
Chikamasa Horiuchi
(b. 1906)
Japanese American
Oil, watercolor, and collage
painter
Biography: Born in
Kawaguchiko, Yamanashi
Prefecture, Japan; studied
sumi brush technique under
Iketani for 3 years in
Kawaguchiko; ca. 1921
moved to the United States
and settled in Rock Springs,
Wyoming; 1946 moved to
Seattle and formed close
association with Mark Tobey;
mid 1950s began collage
work
Exhibited: The Northwest
Annual, SAM, 1930, 1935,
1938, 1947-72; Rome-New
York Art Foundation, Rome,
Italy, and New York, 1958;
Carnegie International, Pitts-
burgh, 1961-64; Seattle
World's Fair, Seattle Center,
1962; Berlin Art Festival,
Germany, 1965; Osaka Art
Fair, Japan, 1970;
Smithsonian Institution,
Washington, D.C., 1974;
SAM, 1979; The National
Museum of Art, Osaka,
Japan, 1982
Solo shows: SAM 1954, 1958,
1969; Zoe Dusanne Gallery,
Seattle, 1957, 1959, 1961,
1963 ; Little Rock Art Mu-
seum, Arkansas, 1959; Uni-
versity of Arizona, Tucson,
1961; Tacoma Art Museum,

1961, 1967, 1987; Utica
Museum, New York, 1965;
Gordon Woodside Gallery,
Woodside/Braseth Gallery,
Seattle, 1965-1987; Foun-
tain Gallery, Portland, 1969,
1971, 1973; University of
Oregon Museum of Art,
Eugene, 1969
Sources:
Appleton, 1941
Paul Horiuchi, SAM, 1958
Read, Sir Herbert, ed.,
Moments of Vision (Rome-New
York Art
Foundation, Inc., 1959)
Northwest Art Today, Seattle
World's Fair catalog
(Portland: Abbott, Kerns and
Bell Company, 1962)
Weller, Allen S., ed., Twelfth
Exhibition of Contemporary
American Painting and Sculpture
(Urbana: University of
Illinois Press, 1965)
Dwight, Edward, H., Four
Artists in Five Media
(Munson-Williams-Proctor
Institute Catalog, 1965)
Paul Horiuchi: 50 Years of Painting
(Seattle and Eugene: SAM
and University of Oregon
Art Museum, 1969)
Kingsbury, 1974, 1978,
1989
Tsutakawa & Lau, 1982
Pacific Northwest Artists and
Japan (National Museum
of Art, Osaka, Japan, 1991)
Guenther, 1993
Horiuchi, Tacoma Art
Museum, 1987
Johns, 1990
ASDSPL
MALUW
SAML

HOSODA, Kuraju
(b. 1885)
Japanese American
Watercolor and oil painter
Biography: Born in Japan
Exhibited: SAM (date un-
known)
Sources:
Appleton, 1941

ISHII, Kowhoo
Japanese American
Oil painter
Biography: Lived in Seattle;
painted landscapes
Exhibited: The Northwest
Annual, SAM, 1924-25
Sources:
Pierce, 1924-26

JUE, Priscilla Chong
(b. 1916)
Chinese American
Textile artist
Biography: Born in Fragaria,
Washington; studied at
University of Washington
for one year; worked with
husband Fay Chong on crafts
Exhibited: Bellevue Arts and
Crafts Fair, each year for 24
years
Sources:
Tacker, Harold and Sylvia,
Band Weaving, New York:
Van Nostrand Reinhold
Company, 1974
SAML

KATAYAMA, Francis (Mits)
Mitsuru (b. 1929)
Japanese American
Watercolor painter, pen-and-
ink illustrator and designer
Biography: Born in Auburn,
Washington; 1948 attended
Edison Technical Institute,
Seattle; 1942-45 was held in
an internment camp in Idaho;
1950-54 served in the U.S.
military; 1954-56 employed
at Studio Art, at Craftsman
Press Inc., Seattle, and 1958-
84 at Graphic Studio,
Seattle; currently in business,
Grafikat; taught at Seattle
Central Community College
and School of Visual
Concepts, Seattle
Sources:
The Seattle Times, May 14, 1967

KIMURA, Fumiko
b. 1929)
Japanese American
Brush and collage painter

Biography: Born in Rexburg,
Idaho; 1954 B.S. in Chemis-
try and 1977 M.A. in Art
Education, University of
Puget Sound, Tacoma; 1985
attended Kyoto Nanga
School, Japan
Exhibited: Tacoma Art
Museum, 1984-85; Bellevue
Art Museum, 1988;
Bumbershoot, Seattle Center,
1988
Solo shows: Washington State
Historical Museum, Tacoma,
1961; University of Puget
Sound, Tacoma, 1977;
Pacific Lutheran University,
Tacoma, 1981; Olympic
College, Bremerton, Wash-
ington, 1982-83; The
Evergreen State College,
Olympia, 1986; Wing Luke
Asian Museum, Seattle, 1988
Sources:
MALUW

KIRA, Hiromu (b. 1898)
Japanese American
Photographer
Biography: Born in Waipahu,
Oahu, Hawaii; moved to
Kumamoto Prefecture, Japan,
at age of four; 1914 moved
to Vancouver, British Colum-
bia; moved to Seattle; learned
how to process and retouch
photographs from a friend
who had a portrait studio;
1926 moved to Los Angeles
and became an influential
figure among Japanese Ameri-
can amateur photographers
Exhibited: Los Angeles
County Museum of Art,
1980; Oakland Museum,
California, and Whitney
Museum of American Art,
New York, 1988
Sources:
Japanese Photography in America
1920-1940 (Los Angeles: Los
Angeles Valley College, 1982
Monroe, 1982
Reed, 1986

KISHIDA, Carl Michio
(b. 1948)
Japanese American
Sculptor and ceramist
Biography: Born in Honolulu; 1972 B.A. and 1974 M.F.A. in Sculpture, University of Washington
Exhibited: HAG,UW, 1971-73, 1975; Cheney Cowles Memorial Museum, Spokane, 1971; Wing Luke Asian Museum, Seattle, 1973; Portland Art Museum, 1973-74; Tacoma Art Museum, 1976; Edmundson Pavilion, University of Washington, 1982; Bumbershoot, Seattle Center, 1986-87
Solo shows: Penryn Gallery, Seattle, 1971-72
Sources:
MALUW

KOIKE, Kyo (1877-1947)
Japanese American
Photographer
Biography: Born in Shimane Prefecture, Japan; a physician in Okayama Prefecture; 1916 moved to Seattle; 1917 began a medical practice; 1919-24 translated over 30 volumes of literature from Japanese to English; won many awards in national and international competitions
Exhibited: Europe and the United States, various sites
Sources:
Kingsbury, 1972
Monroe, 1982
Reed, 1986
M&SCALUW
SAML

KOREKIYO, Tsuyoshi
(b. 1912) and Misao (b. 1919)
Japanese American
Calligraphers
Biography: Tsuyoshi was born in Seattle and Misao in Corinne, Utah; both were educated in Japan and 1954-62 received private lessons from Oudo Katayama; 1975-

87 both taught calligraphy in Seattle; submitted annually to Yomiuri and Mainichi Newspaper and entered calligraphy competitions, including the International Sankei Calligraphy competition in Japan

KUBOTA, Fujitaro
(1880-1973)
Japanese American
Landscape designer
Biography: Born in Kochi Prefecture, Japan; graduated from high school and attended agricultural school in Japan; Dec. 16, 1906, landed at Hawaii; 1906 moved to Seattle; 1923 opened gardening business; 1929 began construction of the Kubota Gardens
Sources:
Kreisman, Lawrence, *Historic Preservation in Seattle* (Seattle: Historic Seattle Preservation and Development Authority, 1985)

KUNISHIGE, Frank
Asakichi (1878-1960)
Japanese American
Photographer
Biography: Born in Yamaguchi Prefecture, Japan; 1896 moved to the United States, landing at San Francisco; ca. 1911 attended photography school in Illinois; 1917 moved to Seattle; worked in the darkroom of the Curtis studio and Ella McBride Studios and for the Bon Marche and Frederick and Nelson department stores, Seattle; introduced photographic printing paper made out of Japanese rice paper known as Textura Tissue
Exhibited: Europe and the United States, various sites
Sources:
Monroe, 1982
Reed, 1986
MALUW

KWEI, Dun
Chinese American
Brush painter and sculptor
Biography: Born in Soochow, China; brush painted with fingers, palm, and nails dipped in Chinese ink; taught art at University of Washington; won a scholarship to study at Harvard University, Cambridge, Massachusetts
Exhibited: HAG,UW, 1928
Sources:
ASDPL

KWEI, Teng
Chinese
Biography: Student at University of Washington; circa 1922 taught calligraphy to Mark Tobey; mid-1920s returned to Shanghai
Sources:
Mark Tobey Papers, MALUW

LAIGO, Valeriano
Emerenciano Montante
(1930-1992)
Filipino American
Painter
Biography: Born in Naguilian, La Union, Philippines; 1931 moved to the United States; 1941 moved to Seattle; 1954 B.A. in Education, Seattle University; 1956-57 studied at Mexico City College (now University of the Americas); 1964 M.F.A. in painting, University of Washington; 1965-85 taught at Seattle University
Exhibited: The Northwest Annual, SAM, 1952-55, 1957-59, 1961-63; University of Arizona Art Gallery, Tucson, 1967; Urban League Annual, Seattle, 1978; Seattle University, 1969, 1980; Wing Luke Asian Museum, Seattle, 1979
Solo and small group shows: Instituto Mexicano Norte-Americano de Relaciones Culturales,

Mexico City, 1958; Zoe Dusanne, Seattle, 1963; Frye Art Museum, Seattle, 1969; Seattle University, 1985; Wing Luke Asian Museum, Seattle, 1989; Seattle University, 1967; double triptych murals at the Dr. Jose P. Rizal Park, Seattle, 1981
Sources:
ASDPL
MALUW
SAML

LEE, Su Jan Dr. (b. 1902)
and Mrs. Lee
Chinese American
Brush painters
Biography: Dr. Lee was born in Peking and Mrs. Lee in Shanghai, China. He moved to the United States in 1916, and she in 1945; he received a B.A. at Colby College in Waterville, Maine, M.A. at Clark University, Worcester, Massachusetts, Ph.D. in law from Futan University, Shanghai, 1933. She attended the College of Arts and Crafts in Oakland, California and did graduate work at the University of California. In 1956 they married and moved to Seattle; 1959 established Academy of Oriental Arts
Sources:
ASDPL

LEO-GWIN, Cheryll
(b. 1944)
Chinese American
Jeweler, ceramist, enamelist and sculptor
Biography: Born in Vancouver, British Columbia; became U.S. citizen; 1975 B.F.A. and 1977 M.F.A. University of Washington; taught at North Seattle Community College, 1971-81, 1984-85 and at Pratt Fine Arts Center, Seattle, 1983-84, 1990
Exhibited: HAG,UW, 1971, 1973, 1975; Honolulu Art

Academy, 1975; SAM, 1976; Phoenix Art Museum, 1977; Bronx Museum, New York, 1978; Philadephia Museum of Art, 1981; University of Kansas, Lawrence, 1981; Wing Luke Asian Museum, Seattle, 1984; Visual Arts Center of Alaska, Anchorage, 1984; Taft Museum, Cincinnati, 1987; Tacoma Art Museum, 1989; Bellevue Art Museum, 1990
Solo and two-person shows: King County Art Museum Gallery, Seattle, 1984; Corvallis Center for the Arts Oregon, 1987; Center Gallery, Seattle Pacific University, 1990
Sources:
Mathews, Glenice, *Enamels, Enameling, Enamelists*, Radnor, Pennsylvania: Chilton Book Co., 1984

LIN, Henry H.
(1918-1989)
Chinese American
Ceramist
Biography: Born in Peking, China; 1942 B.A. Fukien Christian University, Foochow, China; 1956 M.F.A. at University of Washington; 1957 fall and 1956 spring quarters taught extension classes at University of Washington; 1958 went to Ohio University, Athens and 1972-84 served as Dean of Fine Arts; father of Maya Lin
Exhibited: HAG,UW, 1954; Syracuse Museum of Fine Arts, New York, 1957
Sources:
MALUW

LIU, Lucy, or Yu-kuang Liu
(b. 1926)
Chinese American
Ink and color brush painter
Biography: Born in Shin Yuong City, Manchuria, China; moved to Taiwan at

e of 23; 1964 studied art
National Art College,
ipei, Taiwan, and 1972
inese and English Litera-
re, Tamkon College, Taipei,
iwan; 1973 moved to the
ited States; 1975 B.F.A.
d 1976 M.A. in Art Educa-
n at Eastern Washington
iversity, Cheney
hibited: Bellevue Art
useum, 1977; Wing Luke
an Museum, Seattle,
7, 1984; Frye Art
useum, Seattle, 1982;
ster/White Gallery,
attle, 1987
rces:
e Seattle Times, Aug. 10, 1988

OUIE, Art (b. 1918)
inese American
l and acrylic painter
graphy: Born in Seattle;
40 B.A. in Liberal Arts,
iversity of Washington;
62-69 owned restaurants
Louie's and 1968-77 Art
uie's Uptown, where he
hibited his paintings;
70s studied painting with
lliam Ivey at Highline
mmunity College, Seattle
hibited: Greenwood
llery, Seattle, 1981
rces:
e Seattle Times, April 18,
73; March 16, 1975

JI, Yuen (1910-1974)
inese American
mmercial photographer
graphy: Born in
angtung, China; moved to
United States at age 12;
died commercial art at
rnish School, Seattle;
died at Chao-Chen Yang's
rthwest Institute of
otography, Seattle; worked
Frederick and Nelson,
attle, in the window dis-
y department, and for the
eing Co., Seattle, as a
aftsman; 1948 opened
n Lui Studio, a photo

studio, Seattle, and in 1950
opened a second Seattle
studio as well as studios in
Tacoma, and Portland
Sources:
Seattle Post-Intelligencer,
March 4, 1962
The Seattle Times,
March 25, 1974

LUI, Wah (b. 1937)
Chinese American
Photographer
Biography: Born in
Kwangtung, China; in 1950
at age 13 summoned to Se-
attle by his father, Yuen Lui;
1968 took over Yuen Lui
Studios; owns 14 photogra-
phy studios
Exhibited: Massachusetts
Institute of Technology,
Cambridge, 1981; SoHo
Photo, New York, 1982;
Florida Institute of Technol-
ogy, 1985; Clark College,
Vancouver, Washington,
1987; University of Oregon,
Museum of Art, Eugene,
1988; Center of Contempo-
rary Art, Seattle, 1989;
Tacoma Art Museum, 1989;
Wing Luke Asian Museum,
Seattle, 1989
Solo shows: Equivalents
Gallery, Seattle, 1985;
Washington State University,
Pullman, 1986; Silver Image
Gallery, Seattle, 1987; Lois
Flury Gallery, Seattle, 1989;
Mind's Eye Gallery, Idaho,
1990; Gallery of Fine Arts,
Daytona Beach, Florida,
1991
Sources:
Photographer's Forum, Feb. 1985
Friends and Strange Dreams, 1985

LUKE, Keye (1904-1991)
Chinese American
Illustrator and actor
Biography: Born in
Kwangtung, China; moved
to Seattle at age 4; attended
Franklin High School; illus-
trations appeared in art

magazine Town Crier,
Seattle; 1926-27 worked on
a mural for the Bon Marche,
Seattle; 1920s and 1930s
exhibited in Seattle, Santa
Barbara, California, and Los
Angeles; 1927 moved to Los
Angeles; produced sets, illus-
trations, and commercial art
for movie studios; 1934
began acting career; 1934-39
starred as number one son of
Charlie Chan for 20th
Century-Fox film series;
1972-75 played the kung-fu
master in A.B.C. T.V. series
"Kung Fu"
Sources:
ASDPL

MACAPIA, Paul M.
(b. 1934)
Filipino American
Photographer
Biography: Born in Manila,
Philippines; 1945 moved to
United States with family;
1959 B.A. in Science-
Anatomy, University of
Chicago; 1963-72 worked
as a medical photographer/
illustrator/director at
Department of Medical Pho-
tography, University of
Washington, Harborview
Hospital, and the Mason
Clinic/Virginia Mason
Medical Center, Seattle; since
1972 chief photographer,
SAM
Exhibited: University of
Oregon, Eugene, 1973;
SAM, 1972, 1975, 1976-78,
1980
Sources:
SAML

MATSUDAIRA, John
(b. 1922)
Japanese American
Painter
Biography: Born in Seattle;
1928 moved to Kanazawa
City, Ishikawa Prefecture,
Japan; 1935 moved back to
Seattle; served in World War

II with the 442nd Regimen-
tal Combat Team; circa
1949-51 attended Burnley
School of Art, Seattle, and
studied there with Jacob
Elshin and Nick Damascus;
late 1940s to early 1950s
sketched with George
Nomura, Paul Horiuchi, and
George Tsutakawa
Exhibited: International Art
Exhibition, Chinatown,
Seattle, 1951-52; Zoe
Dusanne Gallery, Seattle,
1954; Woessner Gallery,
Seattle, 1958; SAM, 1977
Sources:
ASDPL
MALUW
SAML

MATSURA, Frank, or Sakae
Matsuura (1874-1913)
Japanese American
Photographer
Biography: Born in Tokyo;
orphaned at age 5; 1901
moved to Seattle/Tacoma;
1903 moved to Okanogan,
Washington; owned a photo
studio in Okanogan County;
his photos appeared in the
Okanogan Independent
Exhibited: Alaska-Yukon-
Pacific Exposition, Seattle,
1909; SAM, 1989; Wing
Luke Asian Museum, Seattle,
1989; Tacoma Art Museum,
1989
Sources:
Roe, JoAnn, *Frank Matsura:
Frontier Photographer* (Seattle:
Madrona Publisher, 1981,
Japanese edition with new
foreword, Tokyo: Heibonsha,
1983)
Roe, JoAnn, *Real Old West*
(Vancouver, British Columbia:
Douglas and McIntyre, 1981)
Brewster, David, ed., *Washing-
tonians* (Seattle: Sasquatch
Books, 1988)
"Home from the Eastern
Sea," KCTS-TV documen-
tary, 1989

MATSUSHITA, Iwao
(1892?-1979)
Japanese American
Writer and photographer
Biography: Born in Miike,
Fukuoka Prefecture, Japan;
1919 came to Seattle; rela-
tive of Kyo Koike; 1946-?
taught Japanese language,
University of Washington
Sources:
The Seattle Times (Sept. 8, 1966)
M&SCALUW

MIYAZAKI, Shiro
(1910-1940)
Japanese American
Oil and watercolor painter,
linoleum printmaker
organizer
Biography: Born in Nara,
Japan; 1928 moved to the
United States; attended
California School of Fine
Arts, San Francisco; friend
of George Tsutakawa; worked
as a labor union organizer
Exhibited: The Northwest
Annual, SAM, 1932-33,
1936, 1938; the Northwest
Printmakers Annual, SAM,
1940; Art Institute of
Chicago, date?
Solo shows: SAM, 1939
Sources:
Appleton, 1941
MALUW, in an interview
with George Tsutakawa,
Northwest Oral History
Project, Archives of American
Art, 1983
Tsutakawa & Lau, 1982

MONIZ, Haruko (b. 1924)
Japanese American
Painter
Biography: Born in Maebashi
City, Gunma Prefecture,
Japan; 1944 B.A. in Art,
Tokyo Women's Art College
Exhibited: Olympia Museum,
1969-70; State Capitol
Museum, Olympia, 1971-74,
1976-81, 1984, 1989;
Tacoma Art Museum, 1971;
Frye Art Museum, Seattle,

1979; Bellevue Art Museum, 1979-81, 1984
Sources:
The Sunday Olympian, Aug. 16, 1981
The Daily Chronicle, Centralia, July 6, 1984

MORINAGA, Yukio
Japanese American
Photographer
Biography: Moved to Seattle from Yamaguchi Prefecture, Japan; worked for Virna Haffer photo studio, Tacoma; developed negatives for many members of Seattle Camera Club
Sources:
Monroe, 1982

NAKASHIMA, George
(1905-1990)
Japanese American
Furniture maker
Biography: Born in Spokane; 1928 attended the Ecole Americaine des Beaux Arts, Fontainebleau; 1929 B.A. in Architecture, University of Washington; 1930 M.A. in Architecture, Massachusetts Institute of Technology, Cambridge, Mass.; 1941-42 established first furniture shop in Seattle until internment forced its closure; 1946 established a furniture-making business in New Hope, Pennsylvania
Exhibited: Museum of Modern Art, New York, 1951; Museum of Contemporary Crafts, New York, 1957, 1964; Akron Art Institute, Ohio, 1962; Nelson Gallery-Atkins Museum, Kansas City, Missouri, 1967; Renwick Gallery, Smithsonian Institution, Washington, D.C., and Minnesota Museum of Arts, Minneapolis, 1972; Cincinnati Art Museum, 1975; Museum of Fine Arts, Boston, 1979

76

Solo shows: American Craft Museum, New York, 1989
Sources:
Nakashima, George, *The Soul of a Tree: A Woodworker's Reflections* (Tokyo, New York, and San Francisco: Kodansha International Ltd, 1981)
Stone, Michael A., *Contemporary American Woodworkers* (Salt Lake City, Utah: G.M. Smith, 1986)
Ostergard, Derek E., *George Nakashima, Full Circle* (American Craft Museum of the American Craft Council, New York: Weidenfeld and Nicolson, 1989)

NAMKUNG, Johsel
(b. 1919)
Korean American
Photographer
Biography: 1937 left Korea to study music at Tokyo Conservatory of Music; 1941 married Mineko Suematsu; 1945-47 taught music in Shanghai, China; 1945-47 manager of Seoul Symphony Orchestra, Korea; 1947 moved to Seattle; 1948-50 graduate studies in singing, University of Washington; 1957 began study of photography, learning all phases of color photography with Chao-Chen Yang; 1961-81 Scientific Photographer, University of Washington
Exhibited: Focus Gallery, San Francisco, 1973; HAG,UW, 1974, 1981; Foster/White Gallery, Seattle, 1977, 1981; SAM, 1978-81; Kobe Portopia, Japan, 1981; National Museum of Art, Osaka, Japan, 1982; State Capitol Museum, Olympia, 1982
Solo shows: HAG,UW 1966, 1972-73; Reed College, Portland, 1967; SAM, 1978; Foster/White Gallery, Seattle, 1978, 1980, 1986; Les Musées du Chateau des

Ducs de Bretagne à Nantes, France, 1982; University of California at Santa Cruz, 1985; Chongqing Photographers Association and Shanghai Photographers Association, China, 1986
Sources:
Pacific Northwest Artists and Japan (Osaka: The National Museum of Art, 1982)
MALUW
SAML

NAMKUNG, Mineko
(b. 1918)
Japanese American
Painter
Biography: Born in Taipei, Taiwan; father was Isamu Suematsu, an oil painter; Mineko attended Toyo Conservatory of Music, Tokyo; 1957-62 owned Hanga Gallery in Seattle
Exhibited: HAG,UW, 1963; Cheney Cowles Museum, Spokane, 1963; The Northwest Annual, SAM, 1964, 1966, 1967; Wing Luke Asian Museum, Seattle, 1969, 1979
Solo shows: Kiku Gallery, 1972
Sources:
MALUW

NISHII, K.
Japanese American
Painter
Biography: Lived in Seattle
Exhibited: The Northwest Annual, SAM, 1925
Sources:
Pierce, 1924-26

NOMA, Yoshio (b. 1914)
Japanese American
Photographer
Biography: Born in Everett, Washington; was sent to Wakayama Prefecture, Japan, for education at age 6; returned to Everett at age 18; 1930s took watercolor class taught by Louis H.

William; 1935 moved to Seattle; 1937 became interested in photography; visited Kyo Koike around this time; 1941 began to send photographs to competitions; 1941-80, 122 prints were accepted by 79 photo salons
Exhibited: Japanese Chamber of Commerce, Seattle, 1940; SAM, 1951; Mariners' Museum, Newport News, Virginia, 1954; Smithsonian Institution, Washington D.C., 1954; Garden State Plaza, Paramus, New Jersey, 1961
Solo shows: Seattle Center, 1963
Sources:
Photo Maxima (New York: Photographic Society of America, 1958)
Monroe, 1982

NOMURA, George
(b. 1930)
Japanese American
Painter
Biography: Born in Seattle, only son of Kenjiro Nomura; 1956 began to paint
Exhibited: The Northwest Annual, SAM, 1959-60; David Hall-Coleman Gallery, Seattle, 1961
Sources:
The Seattle Times, March 20, 1961

NOMURA, Kenjiro
(1896-1956)
Japanese American
Oil and watercolor painter
Biography: Born in Gifu Prefecture, Japan; 1907 summoned by his father to Tacoma; 1920s attended art classes at Tadama Art School in Seattle, taught by Fokko Tadama; early 1950s moved from realist to abstract style; 1954 received U.S. citizenship
Exhibited: The Northwest Annual, SAM, 1922-23,

1925-26, 1931-34, 1936, 1938, 1947, 1953; Museum of Modern Art, New York, 1933; Zoe Dusanne Gallery, Seattle, 1953; International Art Exhibition, San Paulo, Brazil, 1955
Solo shows: SAM, 1933, 1960; Wing Luke Asian Museum, Seattle, 1991
Sources:
Pierce, 1924-26
Paintings and Sculptures from 16 American Cities (New York: Museum of Modern Art, 1933)
McCaffrey, 1937
Appleton, 1941
Pacific Coast Art: United States' Representation at the Third Bienale of Sao Paulo, San Francisco Museum of Art, 1956
Kingsbury, 1974
Tsutakawa & Lau, 1982
ASDPL
MALUW
SAML

OGAWA, Elmer
(1905-1970)
Japanese American
Commercial photographer
Biography: Born in Seattle; attended Queen Anne High School, Seattle; majored in Foreign Trade at University of Washington; columnist-photographer for the Pacific Citizen, publication for the Japanese American Citizens League
Sources:
M&SCAUW

OHNISHI, Hideo
Japanese American
Photographer
Biography: Returned to Japan before World War II
Solo shows: Japanese Commercial Club, Seattle, 1926
Sources:
Monroe, 1982
Reed, 1986

KA, Keith (b. 1916)
[Ja]panese American
[g]raphic designer, printmaker,
[w]atercolor, pen-and-ink
[p]ainter
[Bi]ography: Born in Okayama
[P]refecture, Japan; moved to
[S]eattle at age 2; 1937 took
[c]ommercial art class at
[E]dison Vocational School,
[S]eattle; printmaker during
[th]e WPA period; employers:
[1]938-42 and 1945 Crafts-
[m]an Press, Seattle; 1942-45
[a]nd 1950-60 Virgil A.
[W]arren Advertising Agency,
[S]pokane; 1960-? Showacre,
[C]oons, Shotwell, Adams
[A]dvertising Agency, Seattle,
[E]xhibited: Fine Arts Gallery
[o]f Carnegie Institute,
[P]ittsburgh, 1934

KADA, Frank Sumio
[b]. 1931)
[Ja]panese American
[p]ainter
[Bi]ography: Born in Seattle;
[1]946-50 attended
[D]erbyshire School of Fine
[A]rts, Seattle, 1950-51
[E]dison Commercial Art
[S]chool, Seattle, 1951-52
[C]ornish School, Seattle, and
[1]955-56 University of
[W]ashington; 1957 B.F.A. in
[p]ainting, Cranbrook Acad-
[e]my of Art, Michigan; 1958
[s]elected by Art in America as
[o]ne of 100 young American
[a]rtists; since 1969 has
[ta]ught at University of
[O]regon, Eugene
[E]xhibited: The Northwest
[An]nual, SAM, 1954-57,
[1]959, 1964-65, 1970,
[1]976-77; HAG,UW, 1955-
[5]9, 1961-63, 1970; Santa
[B]arbara Museum, California,
[1]957, 1959, 1975; Portland
[Ar]t Museum, 1959, 1971;
[S]eattle World's Fair, Seattle
[C]enter, 1962; Kobe Munici-
[p]al Museum, Japan, 1966;
[M]useum of Modern Art,
[P]aris, 1967; Denver Art

Museum, Colorado, 1971;
Wing Luke Asian Museum,
Seattle, 1977, 1980, 1984;
Osaka National Museum,
Japan and Seattle, 1982;
Tacoma Art Museum, 1986;
Washington State Capitol
Museum, Olympia, 1987;
Cheney Cowles Museum,
Spokane, 1988
Solo shows: University of
Oregon Museum, Eugene,
1970, 1976; Tacoma Art
Museum, 1970; Portland
Museum Art School, 1970;
Portland Art Museum, 1972;
Foster/White Gallery,
Seattle, 1975-77, 1979;
Cornish School of Fine Arts,
Seattle, 1976; Woodside/
Braseth Gallery, Seattle,
1980, 1982, 1985; Blackfish
Gallery, Portland, 1980;
Greg Kucera Gallery, Seattle,
1988; Maveety Gallery,
Portland, 1989
Sources:
Northwest Art Today, Seattle
World's Fair catalog (Port-
land, Oregon: Abbott, Kerns
and Bell Company, 1962)
Pacific Northwest Artists and
Japan (Osaka, Japan:
The National Museum of
Art, 1982)
Guenther, 1983
ASDPL
MALUW
SAML

OKAMURA, Nori
(b. 1924)
Japanese American
Collage painter
Biography: Born in Oakland,
California; attended San
Francisco City College,
1943-45 Chicago Academy
of Fine Arts, 1956-57 The
Museum of Modern Art
School, New York, 1958-60
The New School for Social
Research, New York, and
1960 Pratt Institute, New
York

Exhibited: New Jersey State
Museum, Trenton, 1966,
1969-70; Lehigh University,
Bethlehem, Pennsylvania,
1972; Cheney Cowles
Memorial Museum, Spokane,
1976, 1977; Portland Art
Museum, 1976; Wing Luke
Asian Museum, Seattle,
1979-80; Tacoma Art
Museum, 1979; Albuquerque
Museum of Art, History and
Science, New Mexico, 1980
Solo shows: Miami Museum of
Modern Art, 1972; Kannai
Gallery, Yokohama, Japan,
1973; Kiku Gallery, Seattle,
1975, 1978, 1980
Sources:
Meilach, Dona and Elvie Ten
Hoor, Collage and Assemblage
(New York: Crown Publisher,
1973)
MALUW
SAML

OKAZAKI, Arthur
(b. 1939)
Japanese American
Photographer
Biography: Born in Honolulu;
1967-87 taught at Washing-
ton State University, Pull-
man; since 1987 has taught
at Tulane University,
Louisiana
Sources:
Pullman, Washington 99163,
a catalog (Foster/White
Gallery, Seattle, 1977)

OSAKA, Michi (b. 1927)
Japanese American
Watercolor and sumi painter
and printmaker
Biography: 1984 M.A.,
University of Washington
Exhibited: Washington State
Capitol Museum, 1975-88;
Washington Historical
Society Museum, Tacoma,
1975-86; Tacoma Art
Museum, 1976-78; Wing
Luke Asian Museum,
1981-86; National Arts
Club, New York, 1988;

Bellevue Art Museum, 1988;
Bumbershoot, Seattle Center,
1988; Pacific Lutheran Uni-
versity, Seattle, 1989; Frye
Art Museum, Seattle, 1989;
Beachwood Museum, Ohio,
1989
Solo shows: University of
Puget Sound Law School,
Tacoma, 1983; Evergreen
State College, Olympia,
1983; Wing Luke Asian
Museum, Seattle, 1988;
University of Puget Sound,
Tacoma, 1989
Sources:
The News Tribune, Tacoma,
Sept. 8, 1985; Oct. 27, 1985

PASCUAL, Nemesio A.
(b. 1908)
Filipino American
Painter
Biography: Born in Jones,
Isabela, Philippines; attended
Cornish School, Seattle
Exhibited: SAM, 1936; West-
ern Washington State Fair,
Puyallup, 1937; Interna-
tional Exhibition,
Chinatown, Seattle, 1950s
Sources:
Appleton, 1941

SATO, Norie (b. 1949)
Japanese American
Printmaker, painter, sculptor
and video artist
Biography: Born in Sendai,
Japan; moved to Pittsburgh
at age 5; 1971 B.F.A. in
printmaking, University of
Michigan, Ann Arbor, and
1974 M.F.A. in printmaking
and video, University of
Washington; introduced to
video by Bill Ritchie at the
University of Washington;
directed video programs for
and/or, Seattle; 1980-81
worked with the Center on
Contemporary Art, Seattle
Exhibited: SAM, 1976-77,
1986, 1988; Brooklyn
Museum, New York, 1976,
1978-79; And/Or, Seattle,

1976; Rhode Island School
of Design Museum of Art,
Providence, 1979; Museum
of Modern Art, New York,
1979-80; HAG,UW, 1980,
1986-87; Galerie Petites
Formes, Osaka, Japan, 1980;
Portland Art Museum, 1980-
81, 1985; Los Angeles Insti-
tute of Contemporary Art,
1980; Solomon R.
Guggenheim Museum, New
York, 1981; The Institute
for Contemporary Art,
Virginia Museum of Fine
Arts, Richmond, 1983;
Bellevue Art Museum, 1983;
Memorial Art Gallery, Roch-
ester, New York, 1983; Long
Beach Museum of Art,
California, 1984; Wing Luke
Asian Museum, 1984; Pratt
Institute Manhattan Gallery,
New York, 1987
Solo shows: Whatcom Museum
of History and Art,
Bellingham, Washington,
1980; Linda Farris Gallery,
Seattle, 1981, 1983, 1986-
87, 1989; Vancouver Art
Gallery, British Columbia,
1984; SAM, 1984; Elizabeth
Leach Gallery, Portland,
1989
Sources:
Baro, Gene, Thirty Years of
American Printmaking (Brook-
lyn, New York: Brooklyn
Museum, 1976)
Smith, Robert and Linda
Farris, Eight Seattle Artists
(Los Angeles: Los Angeles
Institute of Contemporary
Art, 1980)
Frank, Peter, 19 Artists:
Emergent Americans (New York:
Solomon R. Guggenheim
Museum, 1981)
The Washington Year:
A Contemporary View,
1980-1981 (Seattle:
HAG,UW 1982)
Guenther, 1983
Johns, 1990
Sato, Norie, "A Question of
Edges" in Breaking Down the

Boundaries: Artists and Museums (Seattle: HAG,UW 1989)
ASDPL
MALUW
SAML

SAWADA, Ikune (b. 1936)
Japanese American
Painter
Biography: Born in Okayama Prefecture, Japan; 1960 B.A. in Western Painting, Art University of Kyoto, Japan; opened a shop in Kobe, Japan, specializing in 17th- and 18th-century Imari ware; 1969 moved to the United States
Exhibited: The Northwest Annual, SAM, 1971-74; Frye Art Museum, Seattle, 1972, 1975; Springville Museum of Art, Utah, 1975; Western Washington State College, Bellingham, 1975; Tacoma Art Museum, 1980; North Seattle Community College, 1986
Solo shows: Francine Seders Gallery, 1972, 1974, 1977, 1979, 1981, 1986; Carnegie Center Gallery, Walla Walla, Washington, 1972; Little Art Gallery, Wenatchee, Washington, 1972; Whatcom Museum of History and Art, Bellingham, Washington, 1975
Sources:
MALUW
SAML

SHIMIZU, Toshi (1887-1945)
Japanese
Oil painter
Biography: Born in Tochigi Prefecture, Japan; 1907 moved to Seattle; 1912 attended Tadama Art School, Seattle; 1917 joined the Art Student League, New York; studied with John Sloan; 1919 returned to Japan; married and in 1920

returned to the United States; 1924 moved to France
Sources:
Japanese Artists Who Studied in U.S.A. and the American Scene (Tokyo and Kyoto: National Museum of Modern Art, 1982)

SHIMOMURA, Roger (b. 1939)
Japanese American
Painter, printmaker, and performance artist
Biography: Born in Seattle; 1961 B.A. in graphic design, University of Washington; 1964 attended Cornish School, Seattle, 1967 Stanford University, Palo Alto, California, and 1968 Cornell University, Ithaca, New York; 1969 M.F.A. in Painting, Syracuse University, New York; since 1978 Professor of Art, University of Kansas, Lawrence; since 1985 has taught performance arts
Exhibited: The Northwest Annual, SAM, 1965-66; Frye Art Museum, Seattle, 1966; University of Washington, 1966-67; HAG,UW, 1967; Lowe Art Center, Syracuse University, New York, 1968-69; Nelson-Atkins Museum, Kansas City, Missouri, 1971-79, 1988; Wichita Art Museum, Kansas, 1973, 1986-87; Arte Fiera '76, Bologna, Italy, 1976; ; Metropolitan Museum and Art Center, Coral Gables, Florida, 1976-77; Cheney Cowles Memorial Museum, Spokane, 1977, 1988; Denver Art Museum, Colorado, 1976, 1978; Indianapolis Museum of Art, Indiana, 1978; Wing Luke Asian Museum, Seattle, 1979-80, 1984; Albuquerque Museum of Art, History and Science, New Mexico, 1980; Hoger Architectur

Institut Sint-Lucas, Ghent, Belgium, 1982; Birmingham Museum of Art, Alabama, 1982, 1984; Bellevue Art Museum, 1986-87; SAM, 1987; Spencer Art Museum, Lawrence, Kansas, 1988
Solo shows: Tacoma Art Museum, 1977; Spencer Museum of Art, University of Kansas, 1979; Birmingham Museum of Art, Alabama, 1982; Center for Contemporary Arts, Santa Fe, New Mexico, 1986; Whatcom Museum of History and Art, Bellingham, Washington, 1986; University of Oregon, Museum of Art, Eugene, 1986; Greg Kucera Gallery, Seattle, 1985, 1988; Bernice Steinbaum Gallery, New York, 1989 Collection: John and Kimiko Powers; METRO Westlake Station, Seattle; Japan Foundation, Tokyo; Syracuse University, New York; University of Washington; Birmingham Museum of Art, Alabama; Metropolitan Museum and Art Center, Coral Gables, Florida; Denver Art Museum, Colorado; SAM; Nelson-Atkins Museum of Art, Kansas City, Missouri
Sources:
Addiss, Stephen and Pat Fister, *Katachi: Form and Spirit in Japanese Art*, Albuquerque Museum (New Mexico: Modern Press, Inc., 1980)
Seto, John H., *Roger Shimomura: Diary* (Birmingham: Birmingham Museum of Art, Alabama, 1982)
Kind, Joshua, *Roger Shimomura: Diary Series* (Dekalb: Northern Illinois University, 1983)
Lew, William W. , Sandra C. Taylor, and John H. Seto, *Journey to Minidoka* (catalog for an exhibition at Weber St. College, University of Utah, Murray State Univer-

sity and Morgan Gallery, 1984)
Lucie-Smith, Edward, *American Art Now* (Oxford: Phaidon, 1985)
Desmett, Don, *Recent Painting and Performance* (Cleveland: Cleveland St. University, 1988)
Mayo, James, M., *War Memorials as Political Landscape* (New York: Praeger, 1988)
MALUW

SUNAMI, Soichi (1885?-1971)
Japanese American
Photographer
Biography: 1920s studied painting and sculpture at the Seattle Art Club; staff photographer for the Museum of Modern Art, New York, for three decades until his retirement in 1968
Sources:
Dance Collection, Performing Arts Research Center, The New York Public Library, New York

TAKASUMI, Fred (b. 1928)
Japanese American
Watercolor painter and illustrator
Biography: Born in Hood River, Oregon; graduated from the Ray Vogue Art School in Chicago; 1958 moved to Seattle; illustrator for The Boeing Co., Seattle
Exhibited: Kiku Gallery, Seattle, 1972
Sources:
The Seattle Times, June 27, 1972

TAKAYOSHI, Henry (1899-1992)
Japanese American
Photographer
Biography: Born in Shimane Prefecture, Japan; 1915 summoned by his father who worked for a greenhouse on

Bainbridge Island, Washington; 1918 began to take photographs
Solo shows: Bainbridge Island branch of Kitsap Regional Library, 1987
Sources:
International Examiner, Jan. 23, 1991

TAKIZAKI, James, or Tamotsu Sebastian Takizaki (1882-1962)
Japanese American
Antique dealer
Biography: Born in Nagano Prefecture, Japan; studied at University of Foreign Languages, Tokyo; ca. 1907 moved to the United States; from early 1950s to circa 1961 owned Far West Antiques

TANAKA, Yasushi (1886-1941)
Japanese
Oil painter
Biography: Born in Tokyo; moved to Seattle at age 17; studied briefly at the Tadama Art School, Seattle; 1916 taught drawing and painting Seattle; 1920 went to Paris, France
Exhibited: Seattle Fine Arts Society, 1914, 1917, 1920; Seattle Public Library, 1917 Schneider Gallery, Seattle, 1919
Sources:
Appleton, 1941
Ford, Hugh, ed., *The Left Bank Revisited: Selections from the Paris Tribune 1917-1934* (University Park and London: The Pennsylvania State University Press, 1972)
ASDPL
MALUW, in the interview with Viola Patterson, Northwest Oral History Project, Archives of American Art, 1982, pp.7-9

THIEL, Midori (b. 1933)
Japanese American
Painter, printmaker, calligrapher, textile artist, and Noh and Kyogen performer
Biography: 1955 B.A., University of California, Berkeley, and 1960 M.A. in Fine Art, University of Berkeley; 1962-67 studied Japanese Koto and Shamisen and 1963 studied Kyogen under Mansaku Nomura and Mannojo Nomura; 1976-79 studied Japanese calligraphy at University of Washington; director of programs for Nippon Kan Theater, Seattle
Exhibited: De Young Museum, San Francisco, 1956; Tokyo Metropolitan Art Museum, 1961; SAM, Portland Art Museum, ca. 1962-65; HAG,UW, 1967; Cheney Cowles Memorial Museum, Spokane, 1978; Wing Luke Asian Museum, Seattle, 1979
Solo shows: San Francisco Museum of Art, 1959; Yoseido Gallery, Tokyo, 1961
Sources:
MALUW

TOKITA, Kamekichi (1897-1948)
Japanese American
Oil painter
Biography: Born in Shizuoka City, Shizuoka Prefecture, Japan; received college education in Japan; 1919 moved to Seattle; operated Noto Sign shop with Kenjiro Nomura, also painted with Nomura and Takuichi Fujii; associated with Kenneth Callahan; 1945 returned to Seattle from internment camp, operated a hotel
Exhibited: Oakland Art Gallery, California, 1929-30; Art Institute of Seattle, 1929-30, 1932 and SAM, 1936, 1948; San Francisco Art Association, the Palace

of the Legion of Honor, 1930-31; Seattle Chamber of Commerce, 1932; SAM, 1934-36, 1939; San Francisco Museum of Art, 1935; Rockefeller Center, New York, 1936
Solo show: SAM, 1935
Sources:
Some Work of the Group of Twelve, 1937
Callahan, Kenneth, "Pacific Northwest Painters," *Art and Artists of Today* (1939?), pp. 6-7
Appleton, 1941
Kingsbury, 1972
Tsutakawa & Lau, 1982
Johns, 1990
ASDPL
MALUW, in the interview with George Tsutakawa, Northwest Oral History Project, Archives of American Art, Smithsonian Institution, 1983
SAML

TOMITA, Genzo
Japanese
Painter
Biography: returned to Japan before World War II
Exhibited: The Northwest Annual, Art Institute of Seattle (now SAM), 1926, 1929-1931
Sources:
Northwest Artists File under Kamekichi Tokita, SAML

TSE, Kei Yuen
Chinese American
Painter
Biography: Born in Honolulu; moved to China and back to Honolulu to attend high school; 1920 attended University of Southern California; moved to Seattle
Sources:
The Seattle Times, Nov. 3, 1935

TSE, Stephen (b. 1938)
Chinese American
Painter
Biography: Born in Hong Kong; 1965 B.A. Washburn University, Topeka, Kansas, and 1967 M.A. University of Idaho, Moscow; has taught at Big Bend Community College, Moses Lake, Washington
Exhibited: Art Institute of Chicago, 1963; Washington State Capitol Museum, Olympia, 1973, 1979-82; Tacoma Art Museum, 1974, 1976, 1978; Cheney Cowles Memorial Museum, Spokane, 1975-76, 1978, 1980-82; The Plain Art Museum, Moorhead, Minnesota; Wing Luke Asian Museum, Seattle, 1979-80, 1983-85, 1987
Solo shows: Carnegie Center, Exhibition Gallery, Walla Walla, Washington, 1976; Jaid Gallery, Richland, Washington, 1976, 1978; University of Oregon, Museum of Art, Eugene, 1977; Kirsten Gallery, Seattle, 1977-78, 1980, 1982, 1985; Fine Art Gallery, Spokane Falls Community College, Washington, 1978; Gallery '76, Wenatchee Valley College, Washington, 1978; Collector's Gallery, Olympia, 1979; Whatcom Museum of History and Art, Bellingham, Washington, 1980
Sources:
MALUW
SAML

TSUTAKAWA, Edward Masao (b. 1921)
Japanese American
Designer, watercolor and mixed media painter
Biography: Born in Seattle; 1940-41 studied art at University of Washington; 1943 attended Chicago Art Institute for three months; 1943 moved to Spokane;

1946 attended Washington State University, Pullman; 1954-80 owned Litho-Art Printer and 1980-present E. M. Tsutakawa Company
Exhibited: The Northwest Annual, SAM, 1950-51; Eastern Washington State Historical Society and Cheney Cowles Memorial Museum, ca. 1946-58
Sources:
The Chronicle (Spokane), June 30, 1957
Spokesman Review (Spokane), June 30, 1975

TSUTAKAWA, George (b. 1910)
Japanese American
Painter and sculptor
Biography: Born in Seattle; at age 7 moved to Fukuyama, Japan, and attended grade school and high school; 1927 returned to Seattle at age 17; attended Broadway High School art classes; 1937 B.A. in Art, under sculptor Dudley Pratt and visiting sculptor, Archipenko (1935), University of Washington; served in U.S. Army during World War II; 1947 married Ayame Kyotani; 1950 M.A. in Art, University of Washington; 1947-76 taught art at University of Washington; 1960 began design and construction of fountain sculptures
Exhibited: The Northwest Annual, SAM, 1934-35, 1939-1941, 1947-1964, 1966-68, 1970; Third Sao Paulo Bienale traveling exhibition, Brazil, 1955; Portland Art Museum, 1955, 1959; HAG,UW, 1954-58, 1971-72; Yoseido Gallery, Tokyo, 1956; Santa Barbara Museum of Art, California, 1959; San Francisco Museum of Art, 1958, 1960; Denver Art Museum, 1960; Seattle World's Fair, Seattle

Center, 1962; Amerika Haus, Berlin, Germany, 1966; Expo '70 Osaka, Japan, 1970; National Gallery of Art, Smithsonian Institution, Washington D.C., 1974; American Academy and Institute of Arts and Letters, New York, 1978, 1981; National Museum of Art, Osaka, 1982; Musée des Beaux-Arts, Carcassonne, France, 1987; Bellevue Art Museum, 1988
Solo shows: Zoe Dusanne Gallery, Seattle, 1953, 1958; SAM, 1957, 1976, 1985; Summer Art Festival, Michigan State University, East Lansing, 1962; Kittredge Gallery, University of Puget Sound, Tacoma, 1965; The HAG,UW 1965; Pacific Northwest Arts Center, SAM, 1976; Foster/White Gallery, Seattle, 1977-78, 1981, 1984, 1986, 1988; Thomas Burke Memorial Washington State Museum, Seattle, 1982; Koko-kan Museum, Sendai, Japan, 1982; Port Angeles Art Center, Washington, 1986; Bellevue Art Museum, 1990
Public Fountain and Sculpture Commissions: Seattle Public Library, 1960; Civic Mall, Fresno, California, 1964; University of Washington, 1967; National Cathedral, Washington, D.C., 1968; City of Sendai, Japan, 1981; Ohkura Park, Tokyo, 1982; Government Center, Toledo, Ohio, 1983; Setagaya Park, Tokyo, 1983; Water Department Building, Sapporo, Japan, 1987
Sources:
Paintings and Sculptures of the Pacific Northwest: Oregon, Washington, British Columbia (Portland Art Museum, 1959)
Birth of a Fountain: Creation of the Seattle Public Library Fountain by George Tsutakawa, Black and

White film, Directed and filmed Don McQuade, 16mm. 30 min., (Seattle, 1960) *Northwest Art Today*, catalog, Seattle World's Fair (Portland, Oregon: Abbott, Kerns and Bell company, 1962) *Fountains in Contemporary Architecture* (American Federation of Arts, 1965) Redstone, Louis, *Art in Architecture* (New York: McGraw-Hill, 1968) Kingsbury, 1974 Kingsbury, 1975 *Franklin D. Murphy Sculpture Garden: An Annotated Catalog of the Collection* (University of Los Angeles, 1976) *Three Northwest Artists: Roethke, Anderson, Tsutakawa*, color/audio, directed by Jean Walkinshaw and filmed by Wayne Sourbeer for Public TV KCTS/9, 16mm, 45 min. (Seattle, 1976) *Sculpture in the Sun* (University Press of Honolulu, Hawaii, 1978) Kingsbury, 1978 *Franklin D. Murphy Sculpture Garden* (Los Angeles: University of California, Los Angeles, 1978) *Northwest Visionaries*, directed and filmed by Ken Levine, Seattle, 1979 *Fountain Sculptures by George Tsutakawa* (City of Sendai, Japan, April, 1981) Tsutakawa & Lau, 1982 *Pacific Northwest Artists and Japan* (Osaka: National Museum of Art, 1982) Guenther, 1983 *Sculpture in Public Places* (Tokyo: Chuokoron-sha, 1983) Interviewed by Martha Kingsbury, Northwest Oral History Project, Archives of American Art, 1983 George Tsutakawa Interview Archives of American Art Videotapes, color, directed by Ken Levine for the

80

Smithsonian Institution, 20 hours (Seattle, 1987) Johns, 1990 Kingsbury, 1990 ASDPL MALUW, SAML

UCHIDA, George (b. 1924)
Japanese American
Photographer
Biography: Born in Seattle; 1943-44 attended Chicago Technical Institute; was a friend of Paul Horiuchi since right after World War II, took photographs for Mark Tobey catalog, Museum of Modern Art exhibit
Sources:
The Seattle Times, April 21, 1961

WARASHINA, Patricia (b. 1940)
Japanese American
Ceramist
Biography: Born in Spokane; 1962 B.F.A. and 1964 M.F.A. at University of Washington; studied with Shoji Hamada, Shinsaku Hamada, Rudy Autio, Takashi Nagasato, Robert Sperry, Harold Myers, Ruth Penington; 1964-65 taught at University of Wisconsin-Platteville; 1966-68 Eastern Michigan University, Ypsilanti; 1969 Cornish School of Allied Arts, Seattle; 1970-present University of Washington
Exhibited: HAG,UW 1961-63, 1971, 1979-80; Everson Museum of Art, Syracuse, New York, 1962, 1964, 1966, 1979; Museum of Contemporary Crafts, New York, 1963, 1966, 1969, 1971; National Museum of History and Technology, Smithsonian Institution, Washington, D.C., 1965; Nelson-Atkins Museum of Art, Kansas City, Missouri, 1969; National Museum of

Modern Art, Kyoto, 1971; American Institute of Architects, Washington D.C, 1971; Victoria and Albert Museum, London, 1972; Santa Barbara Museum of Art, California, 1973; Downtown Branch, Whitney Museum of American Art, New York, 1974; SAM, 1974, 1977, 1979; The Bronx Museum, New York, 1978; Pratt Institute Manhattan Center, New York, 1979; Renwick Gallery, National Museum of American Art, Smithsonian Institution, 1981; American Craft Museum, New York, 1981; Arts Museum, Kanazawa, Japan, 1982; Monterey Peninsula Museum of Art, California, 1982; Antonio Prieto Memorial Gallery, Mills College, Oakland, California, 1982
Solo shows: Grossmont College Gallery, El Cajon, California, 1976; Following Sea Gallery, Honolulu, 1977; Foster/White Gallery, Seattle, 1980; Theo Portnoy Gallery, New York, 1980; Tucson Museum of Art, Arizona, 1982
Sources:
Campbell, David, R., *Contemporary Craftsmen of the Far West* (New York: Museum of Contemporary Crafts, 1961)
American Crafts New Talent 1963 (Normal: University of Illinois, 1963)
Shores, Kenneth and R. Joseph Monsen, *Contemporary American Ceramics from the Collection of R. Joseph Monsen* (Portland: Contemporary Crafts Association, 1967)
Nordness, Lee, Objects: USA (New York: Viking Press and the Museum of Contemporary Crafts, 1970)
Fraser, H., *Kilns and Kiln Firing for the Craft Potter* (New

York: Watson-Guptill, 1974)
Paz, Octavio, *In Praise of Hands: Contemporary Crafts of the World* (Greenvish, Connecticut: New York Graphic Society, 1974)
Stockheim-Schwarz, Judy, *Patti Warashina*, catalog, Grossmont College Gallery (El Cajon, California, 1975)
Warashina, Patti, Artist's Statement, *Contemporary Ceramics: The Artist's Viewpoint* (Kalamazoo, Michigan: Institute of Arts, 1977)
Hall, Julie, *Tradition and Change* (New York: E.P. Dutton, 1977)
Clay From Molds: Multiple, Altered Casting, Combinations, (Sheboygan, Wisconsin: John Michael Kohler Arts Center, 1978)
Brody, Harvey, *The Book of Low-Fire Ceramics* (New York: Holt, Rinehart and Winston, 1979)
Conrad, John W., *Contemporary Ceramic Techniques* (Englewood Cliffs, New Jersey: Prentice-Hall, 1979)
Jones, Virginia, "Sculptural Forms of Selected Twentieth-Century Women," unpublished master's thesis (Denton Texas, Texas Women's University, 1979)
Harrington, 1979
Clark, Garth, and Margie Hughto, *A Century of Ceramics in the United States* (New York: E.P. Dutton, 1979)
Hedges, Elaine and Ingrid Wendt, *In Her Own Image: Women Working in the Arts* (Old Westbury, New York: The Feminist Press, 1980)
Wechsler, Susan, *Low Fire Ceramics* (New York: Watson-Guptill, 1981)
Monroe, Michael W., *The Animal Image: Contemporary Objects and the Beast* (Washington, D.C.: Renwick Gallery, National Museum

of American Art, Smithsonian Institution Press, 1981)
Recent Work-Patti Warashina (Tucson, Arizona: Tucson Museum of Art, 1982)
Harrington, 1982
Levin, Elaine, *The History of American Ceramics* (New York: Watson-Guptill, 1982)
Guenther, 1983
Hopper, Robin, *The Ceramic Spectrum* (Radnor, Pennsylvania: Chilton, 1984)
Levin, Elaine, *The History of American Ceramics* (New York: H.N. Abram, 1988)
Johns, 1990
MALUW
SAML

WONGSANGUAN, Burin (b. 1938)
Thai
Painter and architect student
Biography: Born in Bangkok; 1956 was sent to Indiana to attend high school for four years; 1961 graduated in architecture at University of Washington
Exhibited: The Northwest Annual, SAM, 1959-60
Solo shows: Kinorn Gallery, which he founded, Seattle, 1960
Sources:
ASDPL

YAMAGISHI, Teizo (b.1898)
Japanese American
Painter
Biography: Attended Tokyo Fine Art College
Exhibited: The Northwest Annual, SAM, 1938-39
Sources:
Appleton, 1941

YAMASAKI, Minoru (1912-1986)
Japanese American
Architect
Biography: Born in Seattle; 1934 B.A. in Architecture,

niversity of Washington;
)34-35 attended New York
niversity; 1949 established
chitecture firm, Minoru
imasaki and Associates,
roy, Michigan
ommissions: Saint Louis
irport Terminal, 1956;
nited States
onsulate-General Office
uilding and Staff Head-
uarters, Kobe, Japan, 1957;
cGregor Memorial
ommunity Conference
enter, Wayne State Univer-
ty, Detroit, 1958; Daharan
ir Terminal, Saudi Arabia,
)61; Pacific Science Center,
eattle, 1962; Prentis Build-
g, Wayne State University,
etroit, 1964; William
imes Hall, Harvard Univer-
ty, Cambridge, Massachu-
tts, 1965; Woodrow
/ilson School of Public and
iternational Affairs,
rinceton University, New
rsey, 1965; Temple
eth-EL, Bloomfield Town-
iip, Michigan, 1974; World
rade Center, New York, 1976;
ainier Square Bank Tower,
eattle, 1977; Founder's
lall, Shinji Shumeikai, Shiga
refecture, Japan, 1982
xhibited: Museum of Modern
rt, New York, 1957;
/orld's Fair, Brussels, 1958;
rchitectural League of New
ork, 1959; John Herron Art
istitute, Indianapolis, 1959;
lonolulu Academy of Arts,
)60; De Young Museum,
an Francisco, 1960;
niversity of Washington,
)60; Instituto de Cultura
lispanica, Madrid, Spain,
)65

Sources:
Yamasaki, Minoru, *A Life in
Architecture* (New York and
Tokyo: Weatherhill, 1979)
Emanuel, Muriel, ed.,
Contemporary Architects
(New York: St. Martin's
Press, 1980)
ASDPL
MALUW
SAML

YANG, Chao-Chen
(1910-1969)
Chinese American
Color photographer
Biography: Born in Hangchow
City, Chekian Province,
China; 1927 B.A. in art,
Hsing-Hwa Academy of Arts,
Shanghai; 1934 appointed
Chinese Consulate-General,
Chicago; 1935-39 studied
painting, sculpture and
photography at Art Institute
of Chicago; 1939 transferred
to Seattle as Chinese Deputy
Consul; 1946 studied
motion picture production
and color cinematography at
RKO Studio in Hollywood;
1947-51 director of North-
west Institute of Photogra-
phy and taught courses in
photography to over 400
students; 1951-64 owned
and operated Yang Color
Photography, Seattle
Exhibited: 234 prints at
salons recognized by
Photographic Society of
America since 1944
Solo shows: Seattle Downtown
Public Library, 1941; SAM,
1942
Sources:
MALUW

State of Oregon

CHEN, Bong Wai
(1910-1968)
Chinese American
Watercolor and brush
painter, calligrapher
Biography: Born in
Kwangtung, China; studied
brush painting with Tom
Suey Kwan and Chen
Yum-sun from age 11 to
high-school age; 1937 moved
to the United States; 1944
M.A. in Architecture, Lincoln
University, San Francisco;
original owner of Chinese
Art Studio, Portland
Sources:
Chen, Bong Wai, *Chinese
Painting Lessons* (1966)
Osley, A.S., *Calligraphy and
Palaeography*, (in honor of the
seventieth birthday of Alfred
Fairbank, C.B.E.)
(Cambridge: University
Printing House, 1965)

82

DOZONO, Robert R.
(b. 1941)
Japanese American
Painter
Biography: Born in Okayama
Prefecture, Japan; 1961
studied engineering and
architecture, Oregon State
University, Corvallis; 1969
B.A. in Fine Arts, University
of Oregon, Eugene, and
1971 M.F.A. in Painting;
1971 studied under Herman
Cherry, Pratt Institute, New
York; 1964-67 served in the
U.S. Army in Europe, where
he visited museums; since
1973 has taught at Portland
Community College
Exhibited: Portland Art
Museum, 1970-71, 1977;
SAM, 1975-76; Clark Arts
Center, Rockford College,
Illinois, 1984; Maryhill
Museum of Art, Goldendale,
Washington, 1987; The Art
Gym, Marylhurst College,
Oregon, 1987

Solo shows: Art Center Gallery,
Pacific University, Seattle,
1973; Eastern Washington
Gallery of Art, Eastern
Washington University,
Cheney, 1978; Northview
Gallery, Portland Community
College, 1985; Blackfish
Gallery, Portland, 1987-88;
Lane Community College
Gallery, Eugene, Oregon,
1989
Sources:
National Watercolor Invitational
(Clark Arts Center Gallery,
Rockford College, Ilinois,
1984)
The Oregonian, Jan. 15, 1988

FONG, Wylog
(1896?-1971?)
Chinese American
Oil painter and illustrator
Biography: Born in San
Francisco; ca. 1913 moved
to Portland with his family;
before 1920 moved to San
Francisco and Los Angeles;
was a sidewalk pastel portrait
painter in Chinatown, Los
Angeles
Exhibited: Portland Art
Association, Museum of Art,
1922
Sources:
Rice, Clyde, *A Heaven in the Eye*
(Portland, Oregon:
Breitenbush Books, 1984,
p.24)

FURUYA, Kyuzo
(1888-1929)
Japanese American
Oil and watercolor painter
Biography: Born in Kanagawa
Prefecture, Japan; June 3,
1908 moved to the United
States; 1917 entered The
School of Fine Arts, Port-
land; worked as a regional
reporter for North American
Times (Hokubei Jiji), Seattle
Exhibited: Portland Art
Association, Museum of Art,
1917, 1919, 1921-22, 1927
Solo show: Portland Art

Association, Museum of Art,
1930
Sources:
Pierce, 1924-1926
Rice, Clyde, *A Heaven in the Eye*
(Portland, Oregon:
Breitenbush Books, 1984,
p. 24)
PAM, Registrar's file

GONG, Fred (b. 1923)
Chinese American
Graphic artist
Biography: Born in San
Francisco; moved to Portland
when he was one year old;
from ca. 1929 for 6 years
trained in drawing and water-
color by a private art teacher,
Alice Albrecht; 1947-48
attended Pratt Institute, New
York; became a graphic artist
in New York and Los Ange-
les; worked mostly for
Westinghouse Corporation
Sources:
AUOL

HOY, Kathy (b. 1942)
Chinese American
Sumi and watercolor painter
Biography: Born in
Hangzhou, China; reared in
Taiwan; 1961-66 studied
sumi under Prof. Hwang,
Taiwan, 1963-66 with Mrs.
Shao, Yu-Hsien, Taipei, Tai-
wan; 1965 B.A. in Education,
Taiwan Normal University,
Taiwan and 1969 M.F.A. in
Painting, University of
Oregon, Eugene; since 1971
has taught Chinese brush
painting in Adult Education,
Lane Community College,
Eugene, Oregon
Exhibited: University of
Oregon, Eugene, 1979-80,
1982; Portland State Univer-
sity, 1988
Solo shows: Oregon State
University, Corvallis, 1982;
Opus 5 Gallery, Eugene,
Oregon, 1988

HOY, Harold (b. 1941)
Chinese American
Painter, printmaker, and
sculptor
Biography: Born in Spokane;
1965 B.A. in Art, Central
Washington University,
Ellensburg, 1967 M.F.A. in
Painting and 1969 M.F.A. in
Sculpture, University of
Oregon, Eugene; since 1970
has taught at Lane Commu-
nity College, Eugene,
Oregon; 1980 founded the
Project Space Gallery, Eu-
gene; 1984 co-founded the
New Zone Gallery, Eugene
Exhibited: HAG,UW, 1967;
Portland Art Museum, 1967,
1970-71, 1974-76, 1981,
1985; Cheney Cowles Me-
morial Museum, Spokane,
1968, 1976, 1979; Coos Bay
Art Museum, Oregon, 1968;
University of Oregon Art
Museum, Eugene, 1970,
1974; Northwest Annual,
SAM, 1971; Somona State
University, California, 1979;
Renwick Gallery,
Smithsonian Institution,
Washington, D.C., 1981; San
Jose Museum of Art, Califor-
nia, 1981-82; Wing Luke
Asian Museum, 1984; Public
Image Gallery, New York,
1984; University of Hawaii,
Honolulu, 1985
Solo shows: University of
Oregon Art Museum, Eu-
gene, 1969, 1971, 1979;
University of California at
Santa Cruz, 1973; William
Sawyer Gallery, San Fran-
cisco, 1979; Blackfish
Gallery, Portland, 1981;
University of Northern Iowa,
Cedar Falls, 1989
Sources:
Monroe, Michael W., *Animal
Image: Contemporary Objects and
the Beast* (Washington, D.C.:
Renwick Gallery,
Smithsonian
Institution, 1981)

KEE, Bue (b. 1893)
Chinese American
Oil, pastel, and watercolor
painter and ceramist
Biography: Born in Portland;
attended Museum Art
School, PAM; Arts and
Crafts Society, Portland;
participant in WPA in
ceramics
Exhibited: Portland Art
Museum, 1930, 1933-34,
1936-40, 1944, 1948;
Oregon Ceramic Studio,
Portland, 1940; Meier and
Frank, Portland, 1940
Sources:
Appleton, 1941
Annual exhibition records
of Portland Art Society, PA
Library

KOSUGE, Michihiro
(b. 1943)
Japanese American
Sculptor
Biography: Born in Tokyo;
1965 moved to the United
States; 1961 attended Tokyo
Sumida Technical School of
Architecture; 1970 M.F.A.
in Art, San Francisco Art Ins-
tute; since 1989 has taught a
Portland State University
Exhibited: Portland Art
Museum, 1972-73; Oakland
Art Museum, 1973; San Fran
cisco Museum of
Modern Art, 1973-74; SAM
1980; Cheney Cowles
Museum, Spokane, 1980; Sa
Jose Institute of Contempo
rary Art, California, 1985;
Maryhill Museum of Art,
Goldendale, Washington,
1987; PAM, 1983, 1985,
1987
Solo shows: Blackfish Gallery
Portland, 1979, 1983; Eliza
beth Leach Gallery, Portlan
1987, 1988; Laura Russo
Gallery, Portland, 1990
Sources:
Oregon Biennial Catalog,
PAM, 1987
SAML

LAU, Fook Tai
Chinese
Architect
Biography: 1914 moved to
the United States; went to
California, Chicago, and
Detroit; 1924 B.S. and 1925
M.S. in Architecture, University of Oregon, Eugene;
1926 returned to China
Sources:
AUOL

LEONG, Wing (b. 1934)
Chinese American
Brush painter
Biography: Born in
Kwangtung, China; 1961
B.A. in Art, New Asia
College, the Chinese University of Hong Kong; 1962
moved to the United States;
since 1967 has owned the
Chinese Art Studio, Portland
Sources:
Wing Leong, *Chinese Painting
Step by Step* (Portland, 1974)
Wing Leong, *How to Paint
Bamboo* (Portland, 1979)

MIZUNO, Sadao
(1870-1948)
Japanese American
Oil and watercolor painter
and photographer
Biography: Born in
Kumamoto Prefecture, Japan;
by 1906 moved from Seattle
to Portland; attended
Museum Art School; 1912-
41 managed his own photo
studio, Rose City Photography Studio, Portland; used
the studio to paint; died in
Vanport City when the city
was flooded
Exhibited: The Annual Pacific
Coast Exposition, 1915;
Portland Art Museum, 1917,
1919 22, 1927, 1932,
1936-37, 1940; The Northwest Annual, SAM,
1919-1923, 1927-28,
1930-32
Collections: PAM and Oregon
Historical Society, Portland

Sources:
Appleton, 1941
PAM, Exhibition records

MORIYASU, Kenyu
(1910-1981)
Japanese American
Oil, mixed media, and sumi
painter
Biography: Born in Hiroshima
Prefecture, Japan; 1930-32
studied sumi and Western oil
painting, the Hongo Art
Institute, Tokyo; owned and
managed a machine tool
company in Kure City,
Hiroshima Prefecture, Japan,
during World War II; 1963
moved to Portland; painted
oils for public showing and
painted sumi as a private
hobby
Biography: Portland Art
Museum, 1963-65, 1967,
1970-73; The Northwest
Annual, SAM, 1964, 1967;
Fountain Gallery, Portland,
1966, 1980-81
Solo shows: Oregon State
University, Corvallis, 1965;
Marylhurst College, Oregon,
1966; Civic Center,
Hiroshima, Japan, 1967;
Portland Art Museum, 1973;
Gallery West, Portland,
1974; Coos Art Museum,
Coos Bay, Oregon, 1976;
Carnegie Art Institute, Walla
Walla, Washington, 1977;
Fountain Gallery, Portland,
1979, 1981; The Catlin
Gabel School, Portland,
1981
Sources:
The Oregonian (July 29, 1973;
Jan. 6, 1974)

MURASE, Robert (b. 1938)
Japanese American
Landscape architect
Biography: Born in San Francisco; 1963 B.A., University
of California, Berkeley;
1967-69 graduate student
Kyoto University, Japan;
president of Murase

Associates, Portland
Design projects: Expoland,
Osaka, Japan, 1970;
Sumitomo Museum, Kyoto,
Japan, 1973; Green Center
Aichi Prefecture, Japan,
1974; Myodo Kai, Buddhist
Study Center, Shiga Prefecture, Japan, 1974; Ankeny
Square, Old Town Portland,
1984; Celilo Court, Portland, 1985; N.E.C. America,
Inc., Cascade Courtyard,
Hillsboro, Oregon, 1987;
ODOT Materials Testing
Lab Bldg., Oregon Art Commission, 1987; N.E.C.
America, Inc., Bamboo
Courtyard Hillsboro, Oregon, 1989; Sequent 11, Koll
Business Park, Beaverton,
Oregon, 1990; Japanese
American Historical Garden,
Waterfront Park, Portland,
1990
Sources:
The Oregonian (May 3, 1986;
April 26, 1987; Oct. 20,
1988, Oct. 15, 1989)
Garden Design (Winter
1988; Spring 1989)

NIGUMA, Rose (b. 1915)
Japanese American
Oil and acrylic painter and
printmaker
Biography: Born in Portland;
1947-49 attended PAM
Museum Art School; 1979
B.F.A., Pacific Northwest
College of Art
Exhibited: Index Gallery,
Vancouver, Washington,
1986; Littman Gallery,
Portland State University,
1988

OGASAWARA, Fred
Japanese American
Photographer
Biography: 1924-30 gained
free membership in Oregon
Camera Club, in exchange
for photographic services to
the club; corresponded with
Notan, publication of Seattle

Camera Club, edited by Kyo
Koike
Sources:
Rare Collections, Oregon
Historical Society, Portland

OKADA, Frank Sumio
(b. 1931)
Japanese American
Painter
Biography: Born in Seattle;
1946-50 attended
Derbyshire School of Fine
Arts, Seattle, 1950-51
Edison Commercial Art
School, Seattle, 1951-52
Cornish School, Seattle, and
1955-56 University of
Washington; 1957 B.F.A. in
Painting, Cranbrook Academy of Art, Michigan; 1958
selected by Art in America as
one of 100 young American
artists; since 1969 has
taught at University of
Oregon, Eugene
Exhibited: The Northwest
Annual, SAM, 1954-57,
1959, 1964-65, 1970,
1976-77; HAG,UW, 1955-
59, 1961-63, 1970; Santa
Barbara Museum, California,
1957, 1959, 1975; Portland
Art Museum, 1959, 1971;
Seattle World's Fair, Seattle
Center, 1962; Kobe Municipal Museum, Japan, 1966;
Museum of Modern Art,
Paris, 1967; Denver Art
Museum, Colorado, 1971;
Wing Luke Asian Museum,
Seattle, 1977, 1980, 1984;
Osaka National Museum,
Japan and Seattle, 1982;
Tacoma Art Museum, 1986;
Washington State Capitol
Museum, Olympia, 1987;
Cheney Cowles Museum,
Spokane, 1988
Solo shows: University of
Oregon Museum, Eugene,
1970, 1976; Tacoma Art
Museum, 1970; Portland
Museum Art School, 1970;
Portland Art Museum, 1972;
Foster/White Gallery,

Seattle, 1975-77, 1979;
Cornish School of Fine Arts,
Seattle, 1976; Woodside/
Braseth Gallery, Seattle,
1980, 1982, 1985; Blackfish
Gallery, Portland, 1980;
Greg Kucera Gallery, Seattle,
1988; Maveety Gallery,
Portland, 1989
Sources:
Northwest Art Today, Seattle
World's Fair catalog
(Portland, Oregon: Abbott,
Kerns and Bell Company,
1962) *Pacific Northwest Artists
and Japan* (Osaka, Japan:
The National Museum
of Art, 1982)
Guenther, 1983
ASDPL
MALUW
SAML

PICKETT, Barbara Setsu
(b. 1945)
Japanese American
Fabric artist
Biography: Born in Omaha,
Nebraska; 1968-70 studied
at Ruth Clark's Weaving
Studio, Portland; 1971 B.S.,
Portland State University;
since 1975 has taught at the
University of Oregon
Exhibited: Portland Art
Museum, 1973-75, 1977;
Museum of Art, University
of Oregon, Eugene, 1976;
Renwick Gallery,
Smithsonian Institution,
Washington, D.C., 1980;
Redding Museum and Art
Center, California, 1983;
Lions Gallery. Wadsworth
Atheneum, Hartford,
Connecticut, 1985; Maryhill
Museum of Art, Goldendale,
Washington, 1985; Index
Gallery of Clark College,
Vancouver, Washington,
1986; A. Montgomery Ward
Gallery, University of Illinois, Chicago, 1988; Adams
Memorial Gallery, Dunkirk,
New York, 1988
Solo and small group shows:

Art Gallery, California State University, Fresno, 1973; Statewide Art Services Traveling Exhibition, Oregon, 1973-74; Contemporary Crafts Association, Portland, 1975; Maude I. Kerns Art Center, Eugene, Oregon, 1977; Bush Barn Art Center, Salem, Oregon, 1980, 1983; Corvallis Art Center, Oregon, 1985
Sources:
Gonsalves, Alyson Smith, ed., *Clothing Decoration* (Menlo Park, California: Lane Publishing Co., 1977) Weavers Journal (Vol. 11, No. 4, 1990)

TOMINAGA, Jo
Japanese American
Architect
Biography: Born in Osaka City, Japan; 1916 attended School of Architecture, University of Oregon, Eugene; for two years worked at McKim, Mead and White, New York; served in American Expeditionary Force in France; studied Architecture and City Planning at an art school opened by A.E.F. at Bellevue near Paris; worked at Seymour and Collins, New York
Sources:
Library, Museum of Art, University of Oregon, Eugene

TSUNEMITSU, Joe
Japanese American
Commercial artist
Sources:
Oregon Historical Society, Portland

WONG, Allen Q. (b. 1921)
Chinese American
Calligrapher and graphic designer
Biography: Born in Portland; 1943 B.A. in Drawing and Painting, University of Oregon, Eugene; 1946-48 studied Advertising Design, The Art Center School, Los Angeles; 1948-49 workshop School of Design, New York; 1943 painted murals for USO Center, Eugene, Oregon; 1943 received the Pennell art scholarship, University of Oregon; for 16 years employed in graphic design, New York; 1967 to present has taught graphic design, lettering, and calligraphy at Oregon State University, Corvallis
Exhibited: Department Annual Exhibition, Oregon State University, Corvallis, 1967-present; Steinmetz Bookstore, Offenbach, West Germany, 1985; Stevens Institute of Technology, Hoboken, New Jersey, 1986
Sources:
Martin, Judy, *Complete Guide to Calligraphy* (Cartwell Books, 1985)
Nelson, R.P., *The Design of Advertising* (Dubuque, Iowa: Brown Publishers, 1985)
Weaver, Roger, *Twenty One Waking Dreams* (Parkdale, Oregon: Trout Creek Press, 1985)
AUOL

Introduction to Archival Sources
for Asian American Art History

Designed to highlight the resources of collections relating to the Asian American art world, this guide is a compilation of artists, dealers and galleries whose papers are found in our holdings. The following catalog does not, however, represent a complete listing of every reference to this topic in the Archives.

Arranged alphabetically, the entries represent the wide range of Asian Americans in American art history from artists, jewelry designers, architects to curators, writers, and art dealers.

Each entry identifies the type of collection: papers, interviews or video interviews, and briefly describes the nature of the material. Information about the Archives of American Art holdings is available at the regional offices in Washington, D.C., New York City, Boston, Detroit, Los Angeles, and on the Research Libraries Information Network (RLIN) found in many libraries.

Laela Weisbaum
West Coast Regional Center
Archives of American Art/Smithsonian Institution

A Guide to Archival Sources for Asian American Art History in the Archives of American Art

COMPILED, 1994

BROOKLYN MUSEUM INTERVIEWS OF ARTISTS, 1965-1968
Brooklyn, New York
Interviews: Taped interviews and transcripts of 72 artists conducted for the "Listening to Pictures" program. The artists, including Toshio Odate and Kenzo Okada, discuss their own works in the museum collection

FRANK CHIN
Writer; Seattle, Washington
Papers: The papers of Roger Shimomura include letters from Frank Chin, 1965-1990

ANDREW CHINN
(b. 1915)
Painter; Seattle, Washington
Interviews: 1965 May 24 and 1991 August 9

FAY CHONG (b. 1912)
Painter, Printmaker; Seattle, Washington
Interview: 1965 February 14 and 20

NOBORU FOUJIOKA
Painter; New York, New York
Papers: Nippon Club exhibition catalog, 1924

CHARLES LANG FREER
(1856-1919)
Art Collector; Detroit, Michigan
Papers: Papers concerning Freer's art collecting activity of Asian art includes correspondence, diaries, art inventories, scrapbooks, clippings, and photographs. Correspondence includes letters from Sadakichi Hartmann, Lien Hui Ching Collection, Bunkio Matsuki, Yozo Nomura, K.T. Wong, Yamanaka & Co., and Seaouke Yue

ROBERT HANAMURA
Architect; Detroit, Michigan
Interview: ca. 1977

PAUL HORIUCHI
(b. 1906)
Painter; Seattle, Washington
Video Interviews: Northwest Visionaries Video, a documentary featuring the work of several Pacific Northwest artists including Paul Horiuchi and George Tsutakawa

EITARO ISHIGAKI
(1893-1958)
Painter; New York, New York
Papers: Three photoprints of Ishigaki, ca. 1940

MICHIKO ITATANI
Painter; Chicago, Illinois
Interview: Museum of Contemporary Art, Chicago interviews of artists, historians and dealers, 1979-1983

MIYOKO ITO (b. 1918)
Painter; Chicago, Illinois
Interview: 1978 July 20

CLEMENS KALISCHER
(b. 1921)
Photographer; Stockbridge, Massachusetts
Papers: 276 photographs of artists teaching at Bennington College, Vermont, the MacDowell Colony, Peterborough and Black Mountain College, North Carolina. Artists include Mine Okubo and Wen Ying Tsai

MATSUMI KANEMITSU
(1922-1992)
Painter, Teacher; Los Angeles, California
Papers: Biographical data and correspondence

IKURA KUHAWARA
Printer; Los Angeles, California
Papers: Graphic prints by Sam Francis, printed by Kuwahara, 1970-1984

YASUO KUNIYOSHI
(1889?-1953)
Painter; New York, New York
Papers: Photographs, glass negatives, and one letter, ca. 1920s-1940s

VAL LAIGO (1930-1992)
Painter; Seattle, Washington
Papers: Biographical, correspondence, sketches, art inventories, writings, exhibition announcements, clippings, photographs and video tapes, 1954-1991

MAYA YING LIN
(b. 1961)
Architect; New York, New York
Interview: 1983 March 6

IRVING MARANTZ
(1936-1972)
Painter, Collector; New York, New York
Papers: An inventory of Chinese works of art purchased by Murantz in the 1930s

MIYE MATSUKATA
(1922-1981)
Jewelry designer, Silversmith; Boston, Massuchusetts
Papers: Biographical, correspondence, financial materials, subject files, art works, writings, printed materials and photographs, 1924-1982

MASAHI MATSUMOTO
Curator; San Francisco, California
Papers: A 15-page speech on alternatives to the traditional museum setting in the San Francisco area, 1976

USEUM OF
ONTEMPORARY ART
TERVIEWS, 1979-1983
icago, Illinois
erviews: A documenatary
artists, historians, and art
alers in the Chicago area
luding Michiko Itatani
d Robert Yasuda

EORGE NAKASHIMA
905-1990)
chitect, Craftsman, Wood-
rker, Furniture Designer;
w Hope, Pennsylvania
pers: Biographical, corre-
ondence, subject files,
itings by and about
kashima and printed
aterial, 1950-1991

HSEL NAMKUNG
1919)
otographer; Seattle,
ashington
erviews: 1989 October 5
1991 February 25

PPON CLUB
XHIBITION CATALOG,
24
1 West 93rd Street,
w York, New York
pers: Special exhibition
atalog of Noboru Foujioka,
24

AMU NOGUCHI
. 1904)
ulptor; Long Island, New
rk
erview: 1968 April 22
pers: Three photoprints
Noguchi and his mother,
00 and 1950

ORTHWEST
SIONARIES VIDEO,
77
deo Interview: A docu-
entary featuring the work
several Pacific Northwest
tists including Paul
oriuchi and George
utakawa

TOSHI ODATE
Wood Sculptor; New York,
New York
Interview: Brooklyn Museum
interviews of artists includ-
ing Odate, 1965-1968

KENZO OKADA (b. 1902)
Painter; New York, New York
Interview: Brooklyn Museum
interviews of artists includ-
ing Okada, 1965-1968.
Papers: Eight exhibition
catalogs of Okada's work at
the Betty Parson's Gallery,
1965-1976

FRANK OKADA (b. 1931)
Painter; Seattle, Washington
Interview: 1990 August 16-17

KAKUZO OKAKURA
(1862-1913)
Curator, Poet; Boston,
Massachusetts and Tokyo,
Japan
Papers: Isabella Stuart
Gardner papers, 1760-1956,
includes correspondence
from Okakura and his family

MINE OKUBO
Artist; Black Mountain
College, North Carolina
Papers: Clemens Kalischer
papers, 1946-1966 includes
photographs of Okubo

NAM JUNE PAIK
(b. 1932)
Video Artist; New York, New
York
Video Interview: Outtake and
master copy videotapes
including an interview with
Paik and the complete Paik
synthesis video of Michael
Kovich dancing on Liz
Phillips' Sculpture,
1970-1980

NORIE SATO (b. 1949)
Video Artist, Printmaker,
Painter, Sculptor; Seattle,
Washington
Papers: Project files, exhibi-
tion files, correspondence,
and printed material,
1974-1991

ROGER SHIMOMURA
(b. 1939)
Painter, Printmaker,
Performance Artist;
Lawrence, Kansas
Papers: Resume, correspon-
dence, lectures, performance
scripts, exhibitions files,
business records, grant appli-
cations, artist's statements,
clippings, exhibition catalogs
and printed material

SOICHI SUNAMI
(1885?-1971)
Photographer; New York,
New York
Papers: Sunami's photographs
of Holger Cahill, Isadora
Duncan, Edward Hopper and
others appear in various
collections

MASARU TAKIGUCHI
(b. 1941)
Sculptor; Houston, Texas
Papers: Slides of his work,
exhibition posters and
catalogs and clippings,
1979-1983

CHUZO TAMOTSU
(1891-1975)
Painter; Santa Fe, New
Mexico
Interview: 1964 September 3
Papers: Correspondence,
biographical data, lists of
artworks, photographs,
sketchbook, annotated books,
financial material, a diary,
sketches, prints, and printed
matter, 1920-1982

YASUSHI TANAKA
(1886-1941)
Painter; Seattle, Washington
Papers: Letters from Tanaka
to Frederick Torrey about the
art world, his paintings, and
Paris, 1913-1963

KAMEKICHI TOKITA
(1897-1948)
Painter; Seattle, Washington
Papers: Letters, writings,
diaries, financial records,
art works, family photo-
graphs, and printed material,
1900-1948

GEORGE TSUTAKAWA
(b. 1910)
Sculptor, Painter, Teacher;
Seattle, Washington
Video Interviews: 1987 June
26-27 1988 October 17 to
November 4
Northwest Visionaries Video,
a documentary featuring the
work of several Pacific
Northwest artists including
Paul Horiuchi and
George Tsutakawa
Interview: 1983 September 8-19
Papers: Biographical data,
correspondence, exhibiton
records, project files,
exhibition announcements
and catalogs, and printed
material, 1963-1991

PATRICIA WARASHINA
(b. 1940)
Ceramist, Sculptor; Seattle
Washington
Papers: Correspondence,
biographical data, exhibition
records, writings, journals,
art works, photographs, a
video and printed matter,
1961-1991

TYRUS WONG
Painter, Designer,
Printmaker; Sunland,
California
Interview: 1965 January 30

YAMANAKA GALLERIES
New York, New York
Papers: Eight-page exhibition
catalog listing 75 works by
11 artists of the Japanese Art
Association, 1917

MINORU YAMASAKI
(b. 1912)
Architect; Troy, Michigan
Interview: August 1959

ROBERT YASUDA
(b. 1940)
Painter; Chicago, Illinois
Interview: Museum of
Contemporary Art, Chicago
interviews of artists, histori-
ans and dealers, 1979-1983

CHAO-CHEN YANG
(1910-1969)
Photographer; Seattle,
Washington
Papers: A resume,
unpublished autobiography,
sketches, writings,
clippings, photographs, and
copy prints of Yang's
photographic works, 1945-
1967